THE LITTL...

Michelangelo

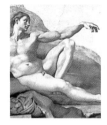

Hélène Sueur
Paul Joannides
Yves Pauwels
Frédérique Lemerle
Amanda Bradley

Flammarion

Michelangelo

Alphabetical Guide

Entries are arranged alphabetically in the following three sections.
(Each section is indicated by a color code.)

The alphabetical entries are cross-referenced
throughout the text with an asterisk (*).

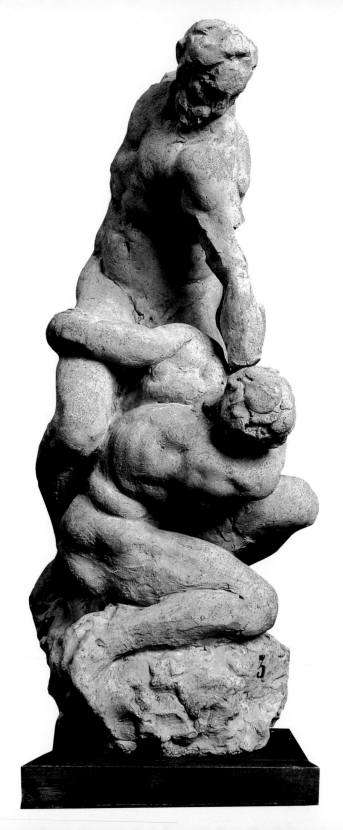

M I C H E L A N G E L O

Knowledge, Difference, Paradox

> "I can make it different, but not better."
> Michelangelo, quoted by Giorgio Vasari
> in *The Lives of the Artists* (1550).

Michelangelo's remark refers to the lantern surmounting the dome of his New Sacristy* for the basilica of San Lorenzo in Florence. The building was commissioned by Pope Clement VII, and was intended to mirror the Old Sacristy, one of the most iconic structures of the early Renaissance by the greatest of all Florentine architects, Filippo Brunelleschi. The domes of both sacristies have a lantern on top, crowned by a metal ball; writing to Clement VII in January 1524, Michelangelo notes that his ball will be faceted rather than smooth, to vary, if not distinguish, it from the other. Michelangelo's letter, and the anecdotal remark, reveal much of his character—he was not dismissive of the achievements of the past; he had deep knowledge of them and profound respect—but he was very confident of his own powers. Competition with the living and the dead animated Michelangelo, but his urge to differ, to stand principles on their head, was not a crude desire to shock, rather, it demonstrated a drive to create new profundities.

It is often noted that Michelangelo's two earliest sculptures, the *Battle of the Centaurs** and the *Madonna of the Stairs**, reflect radically different traditions. The first is in a direct line of descent from the high reliefs of Roman sarcophagi and the thirteenth-century pulpits of the Tuscan sculptor Nicola Pisano; the second from the more pictorial *rilievo schiacciato,* or "flattened relief," developed in the early and mid-fifteenth century by the great Florentine sculptors Donatello and Desiderio da Settignano. Similarly, the drawings generally considered to be Michelangelo's earliest, are copies of works by Giotto and Masaccio, the founding fathers of the first and second phases of Tuscan Renaissance art, corresponding broadly to the Italian trecento and quattrocento (the fourteenth and fifteenth centuries). Clearly, Michelangelo was already aware of his future role as the presiding genius of the third phase (if not its founder, for that is Leonardo da Vinci), as codified by Vasari in the *Lives*, half a century later.

A precocious art historian, the young Michelangelo possessed such understanding and knowledge of the styles and techniques of earlier periods that he was also a successful forger, making copies of drawings

Daniele da Volterra, Sculpture of Michelangelo, c. 1564/1566. Bronze. Accademia, Florence.

Facing page: Michelangelo, Hercules and Cacus, 1518. Clay, h. 16 in. (41 cm). Casa Buonarroti, Florence.

Below, left:
Michelangelo,
Kneeling Angel,
1494–95.
Marble,
h. 20⅓ in
(51.5 cm).
Arca di San
Domenico,
San Domenico,
Bologna.

Below, right:
Michelangelo,
Cupid/Apollo,
c. 1497.
Marble, 37⅓ x
17⅔ x 13 in.
(94.8 x 45 x
33 cm).
Payne
Whitney
House
(headquarters
of the cultural
department of
the French
embassy),
New York.

by earlier masters and returning these to their owners in place of the originals, as a demonstration of his virtuosity. He had the same skill in sculpture. The story of his *Sleeping Cupid*, artificially aged and sold to the Cardinal of San Giorgio, Raffaele Riario, as antique work, is fortunately well documented by contemporaries—otherwise it would certainly have been dismissed as apocryphal.

Knowledge of the past was allied to a wide-ranging awareness of contemporary production. Another work, lost but recorded, was a colored copy of Martin Schongauer's engraving of the *Torment of St. Anthony*, in which Michelangelo made a quasi-Flemish effort to reproduce surfaces and textures with the greatest possible optical accuracy—the fall of light on the scaly skins of his devils was the result of a careful study of fish from a market stall. An interest in unexpected and unlikely detail—a small crab appears in his drawing ofthe*Punishment of Tityus* of 1533—was a feature of his work for many years.

In his version of Schongauer's print, Michelangelo attempted to outdo a difficult model. A subsequent commission to carve three figures for the unfinished tomb of San Domenico in Bologna* pitted him against two more masters, one of the trecento, Arnolfo di Cambio, and the then recently deceased virtuoso marble-carver Niccolò dell'Arca. Michelangelo's two standing figures closely imitate Niccolò's style,

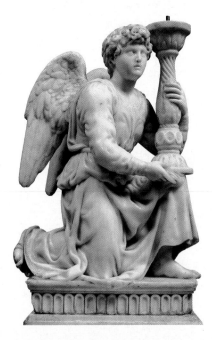
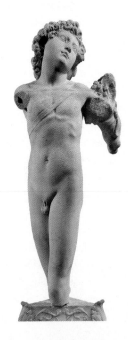

but his kneeling angel takes its starting point in the solidity of Arnolfo's forms and develops them in an entirely personal way. Imitation and innovation co-exist, Michelangelo equally master of both.

Michelangelo's two major statues carved in Rome between 1496 and 1500 could hardly be more different. The *Bacchus** treats a classical theme with a psychological richness—indeed ambivalence—unknown to its antique forerunners, and possesses a three-dimensional complexity far outstripping theirs. By contrast, the *Pietà*, a high relief rather than a free-standing statue, looks to the sleek surfaces of sculpture by the quattrocento Florentine Andrea del Verrocchio, and the svelt drapery forms of Leonardo da Vinci's paintings: it deploys polished and broken surfaces, highlights and shadows with a visual sophistication far beyond the capacity of most contemporary painters. The recently rediscovered *Cupid* of 1497 takes still another model—the elongated forms of antique statuettes in bronze.

An interest in bronze should not surprise us. Vasari tells us that Michelangelo studied at the Medici sculpture garden at San Marco*, under its elderly curator Bertoldo, a sculptor who worked primarily in bronze. Michelangelo strove to recreate the tensile strength of bronze in marble, his own preferred medium. The 360 degree view achieved in the *Bacchus* had previously been attempted by Tuscan sculptors only in metal; Michelangelo's *David* *, carved between 1501 and 1503, is probably the most deeply undercut statue of its size ever undertaken, achieving effects hitherto unimagined in marble. Competition with the properties of bronze continued in Michelangelo's elaborate project for a marble group of *Hercules and Antaeus*, planned in 1505–06, abandoned in 1512, taken up again in 1524, and finally re-projected in 1528 as a *Samson and Two Philistines*. Unsurprisingly, Michelangelo's clay model for the *Samson*, which was never carved, was widely reproduced and circulated in numerous small bronzes.

Cross-media fertilization is a central feature of Michelangelo's work, and in other marbles he invited comparison with painting. The so-called *Bruges Madonna** employs undercut drapery to cast soft shadows around the contours of his figures, as does his relief roundel, the *Taddei Tondo*.

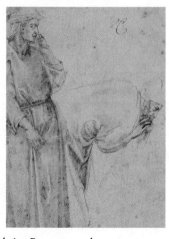

Michelangelo, *Two figures, after Giottto's Ascension of St John the Evangelist in the Peruzzi Chapel, Santa Croce, Florence,* c. 1490. Pen and brown ink, 12½ x 8¼ in. (31.5 x 20.5 cm). Department of Prints and Drawing, Musée du Louvre, Paris.

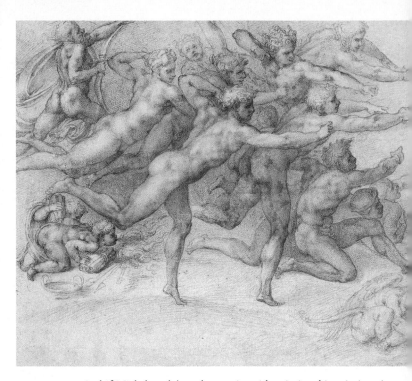

And if Michelangelo's sculpture vies with painting, his painting vies with sculpture. The unfinished *Entombment* in the National Gallery, London, is geometrical and unsparing, imitating the most severe of high reliefs; in contrast, the holy family of the *Doni Tondo**, a group of unprecedented complexity set within that most difficult of fields, the roundel, possesses the solidity of free-standing sculpture. Here, as critics have always noted, Michelangelo responded to Leonardo, outdoing his rival in the construction of a three-figure group, but rendering it in an icy color scheme that is diametrically opposed to Leonardo's soft tonalism. The strong, sculptural presence of Michelangelo's group, conceived in response to the work of another master, expresses a rich metaphoric meaning: Michelangelo forcefully presents the grandeur of the Virgin—the Church—in welcoming and sustaining the holy child, while the massive delicacy of his St. Joseph becomes a powerful image of God bestowing His Son upon humanity.

Sculpture is also the template for the *Battle of Cascina**, Michelangelo's great mural for the Palazzo Vecchio in Florence, a commission which pitted him directly against Leonardo da Vinci. In the preparatory drawings for the mural's central section, known in a later copy as the *Bathers*, Michelangelo grouped a number of nude soldiers, startled by a sudden call to arms while bathing in the river Arno. They are organized within a grid-like arrangement which imposes a strong

pattern upon the picture field, while allowing maximum freedom to the individual parts. Michelangelo provided a radically new range of poses and movements for his actors, creating a forest—as a contemporary described it—of individual statues. This divergence from what might have been expected of the narrative of a battle, gives the image a resonance far beyond the picture's historical pretext—the record of a Florentine victory over the neighboring city of Pisa. Responding to the trumpet call, these nude and semi-nude men reveal their *virtu* and *prontezza*, or 'readiness'. Their anatomies are the anatomies of courage and grace, as they rise from rest like the dead at the Last Judgment. They were not forgotten when Michelangelo came to paint the latter subject in the Sistine Chapel* in Rome, thirty years later.

The massive tomb of Pope Julius II, as planned in 1505, was conceived as a triumphal mountain of seated prophets, sibyls and apostles, large-scale narrative reliefs, standing Victories and tethered prisoners (the *Slaves**). It was heavily influenced by antique models, primarily Roman imperial tombs, victory arches, and the visual and literary records of imperial triumphs. But like the warriors of the *Battle of Cascina*, Michelangelo's figures became embodiments of moral and spiritual qualities; the *Slaves* are at once military and spiritual captives, struggling to escape from the bonds of the body, and images of the soul, universal symbols of the human spirit. The *Victories* metamorphosed from Roman-inspired winged figures trampling their recumbent enemies, to embodiments of virtue vanquishing embodiments of vice. The first scheme was abandoned, to be taken up again in various reduced forms over a period of forty years concluding with the present wall-tomb in San Pietro in Vincoli, much simplified in form and meaning from Michelangelo's earlier schemes.

Michelangelo,
Study for the Battle of Cascina,
c. 1504.
Black chalk,
9¼ x 14 in.
(23.5 x 35.5 cm).
Gabinetto Disegni e Stampe, Galleria degli Uffizi, Florence.

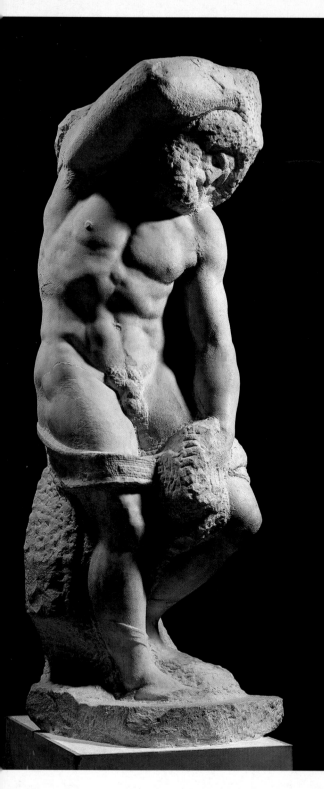

Left:
Michelangelo,
Bearded Slave,
between 1518
and 1530.
Marble,
h. 8 ft. 7½ in.
(2.63 m)
(including
base).
Galleria dell'
Accademia,
Florence.

Facing page,
top left:
Michelangelo,
Youthful Slave,
between 1518
and 1530.
Marble,
h. 8 ft. 5 in.
(2.56 m)
(including
base).
Galleria dell'
Accademia,
Florence.

Facing page,
top right:
Michelangelo,
Atlas Slave,
c. 1534–36.
Marble,
h. 9 ft. 1 in.
(2.77 m)
(including
base).
Galleria dell'
Accademia,
Florence.

Facing page,
bottom:
Michelangelo,
Day and Night
(tomb of
Giuliano
de' Medici),
1526–31.
Marble.
New Sacristy,
San Lorenzo,
Florence.

 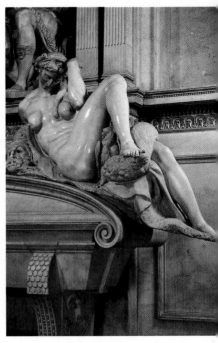

Diverted in 1508 to frescoing the Sistine Chapel*, Michelangelo projected many of the tomb's planned sculptural elements onto his painted ceiling. Prophets and sibyls are seated around the vault's edge, embodying knowledge and vision; the *Slaves* became the *ignudi*, wingless angels, whose pensive or energetic poses reflect the significance of the scenes that they flank. The tomb's reliefs are transposed to become the chapel's Genesis narratives. Here, seeking the means to float his great forms across the vault's surface, Michelangelo looked to unexpected sources for inspiration—the flattened reliefs of the early fifteenth-century Sienese sculptor Jacopo della Quercia, and the linear abstractions of Botticelli. He also chose a dramatically artificial color scheme, high in key, employing color changes rather than light and shade to model forms: a manner alien to contemporary practice, and recalling the early quattrocento in Florence, especially the paintings of Lorenzo Monaco (see Color).

If the tomb was a model for the ceiling, the ceiling in turn affected the façade of San Lorenzo in Florence, commissioned from Michelangelo in 1516. His design reduced the architectural forms proper to a grid, within which were set statues and reliefs. Had the scheme been carried out, it would have functioned more as a pictorial ensemble than as architecture in the conventional sense. When the project was aborted in 1520, Michelangelo was commissioned, partly in compensation, to undertake the wall tombs of four members of the Medici family in the basilica's New Sacristy. Here, too, his detailed and overloaded designs are essentially pictorial in conception, drawing on classical sources for the armored *capitani* (the figures of the recently deceased Giuliano, Duke of Nemours, and Lorenzo, Duke of Urbino), military trophies and symbolic attendant figures. But Michelangelo's vision of the Medici tombs changed as work progressed. The figures reclining on the sarcophagi (*Night, Day, Dawn,* and *Dusk*) gradually lost their specific identities: *Night*, probably the first to be carved, abounds with attributes, but *Dawn*, sculpted later, has none, she seems simply to stir with foreboding into the light. Within the confines of the mausoleum, this realm of the dead, separated from the world, Michelangelo carved statues that transcend allegory. Where eternity reigns, their apparently restless, uneasy postures and motion reactivate time as a perpetual experience of loss, a suffering made the more immediate by their being cast in forms that border on the sensuous. But as with the Sistine Chapel *ignudi*, their longing is spiritual, not physical. The pagan forms of Greek and Roman antiquity are Christianized from within.

In 1534 Michelangelo abandoned Florence to escape a hated regime, leaving the New Sacristy unfinished. He was commanded to paint the *Last Judgment** on the altar wall of the Sistine Chapel in Rome. His vision of the *Dies Irae* is in complete contrast to what was then the most significant High Renaissance treatment of the subject, Fra Bartolommeo's fresco in San Marco, in Florence. Ignoring perspective, Michelangelo created an indefinite space in which figure-groups float, rise or fall, separated from one another like constellations. The scheme recalls Byzantine and Romanesque prototypes. Michelangelo also looked once again to antiquity. The massive forms of the Sins at the painting's right edge recall the classical myth of the Fall of the Giants, a subject recently painted by both Giulio Romano and Perino del Vaga. Struggling against their fate like the giants attacking Mount Olympus, the Sins are damned by the mighty right arm of a beardless Christ whose head is modeled on that of the celebrated antique statue, the *Apollo Belvedere*. The entire fresco is a metamorphosis of antique

Michelangelo, The Crucifixion of St. Peter, 1546–50. Fresco, 20 ft. 6 in. x 21 ft. 8½ in. (6.25 x 6.62 m). Pauline Chapel, Vatican.

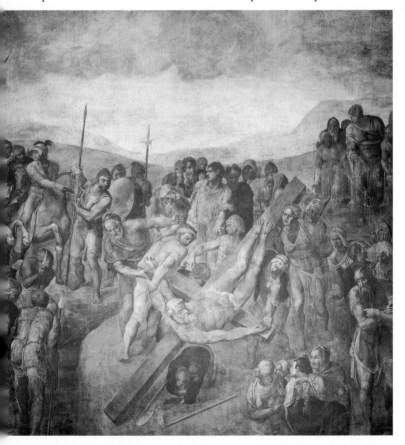

forms and scenes, with Michelangelo demonstrating a command of simile and metaphor comparable to that which animates his poetry: the Virgin's pose is that of a crouching Venus, the saint on the left is a transposed Niobe reunited with—rather than losing—her child.

Once again, the *Last Judgment* is composed as a severe grid. The figures contained within it—many shown in hitherto unimagined attitudes and foreshortenings—were the marvel of his contemporaries. Michelangelo's 'indecent' figures were attacked by Pietro Aretino, the Venice-based poet and satirist, soon after the fresco's completion, and some of the bodies were later veiled by Michelangelo's friend and follower, Daniele da Volterra. Yet they are in truth so thickened and de-sensualized that they are effectively post-sexual beings, animated not by physical desire, but by their devotion to the Savior, their wonder at the prospect of Resurrection, or horror at their fate.

The saints, in the upper right of the composition, face down the damned with the instruments of their martyrdom in a way which might seem crude. Michelangelo realized that such directness was a strength, not a weakness. By relating these massive, brutal objects to the instruments of Christ's passion, carried here by *ignudi* in the upper right and upper left lunettes, Michelangelo presents them as the spiritual and physical justification for the martyrs' own harsh acts of judgment.

Awkwardness and disproportion were central to Michelangelo's last fresco scheme, the *Conversion of St. Paul* and the *Crucifixion of St. Peter* in the Vatican's Pauline Chapel*. For the first time since the *Flood* in the Sistine Chapel, he was executing multi-figure narrative scenes. The inescapable force of God's will dominates Paul's *Conversion*; the silent organization of Peter's flock, his *Crucifixion*. These paintings entirely ignore Renaissance conventions of pictorial depth, precisely in order to achieve spiritual depth. By combining the inflated forms developed in the *Last Judgment*, with a deliberately unrealistic (we might even say "naive") lack of perspective that freely juxtaposes elements rhythmically unrelated and different in scale, Michelangelo harks back to the artistic forms and the fervor of early Christianity, in an attempt to evoke the latter's sense of direct contact with the divine. Energy is reserved for Christ and His angels alone; the earthly actors proceed like spiritual sleepwalkers.

Such retrospection is also seen, more explicitly, in the Pietà drawn by Michelangelo in the early 1540s for his friend Vittoria Colonna. As Michelangelo's biographer Condivi* reports, the cross beneath which the Virgin sits, cradling Christ's body between her knees, was copied

Michelangelo, *Pietà* (for V. Colonna), c. 1540–46. Black chalk, 11⅔ x 7¾ in. (29.5 x 19.5 cm). Isabella Stewart Gardner Museum, Boston.

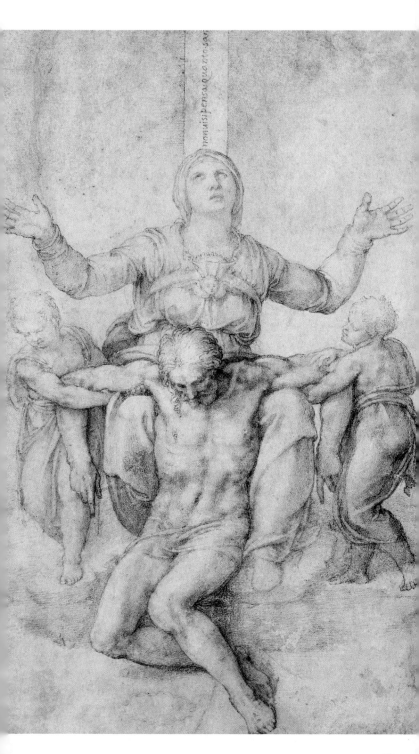

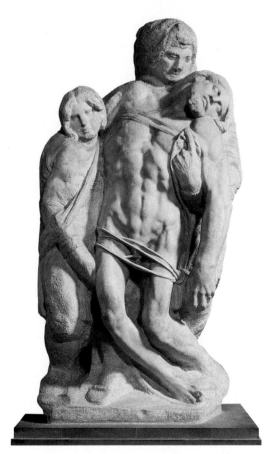

Michelangelo,
*Palestrina
Pietà*, c. 1555.
Marble,
h. 8 ft. 3⅔ in.
(253 cm).
Galleria del'
l'Accademia;
Florence.

from one which Michelangelo believed had been used in a procession of 1348. Its upright bears a quotation from Dante, and the Virgin's solidly-modeled form again recalls the work of Arnolfo di Cambio—another central figure of the Italian trecento. Similar ideas hold sway in works that Michelangelo executed for himself, such as the *Palestrina Pietà* and the *Rondanini Pietà**. The first has the frontality of Romanesque relief; the second recalls trecento sculpture, and the "simulated sculpture" of early fifteenth-century Flanders (the painted Pietàs found on the reverse of panels by Jan van Eyck and Rogier van der Weyden). This "primitivism"—linked in Michelangelo's mind with the direct emotional appeal of popular devotional art—is a common theme in the designs which he drew for paintings by his pupils and friends during the last years of his life. An *Agony in the Garden*, for example, recalls the treatment of the same subject by the early fourteenth-century Sienese painter Duccio di Buoninsegna.

Parallel to his work in painting and sculpture, Michelangelo's architecture—initially conceived as little more than a vehicle for

sculpture—underwent a comparable development. The purely archi-
tectural elements of the tomb of Julius II or the façade of San Lorenzo
offer small poetic or metaphorical content, but Michelangelo's attitude
changed during the mid-1520s when he began to design buildings
free of sculpture. Passing through a building could, he discovered,
become an exciting, emotional journey shaped and punctuated by
columns and tabernacles, volutes and door-frames, changes of plane
and level. He transmuted the rationality of classical architecture into
dramatic plays of force, and employed classical details in new, appar-
ently irrational, ways. For the Laurentian Library* of San Lorenzo,
Michelangelo envisaged just such an exciting sequence of spaces. The
walls of the *ricetto*, or anteroom, are rich with architectural features.
They are articulated with pairs of supporting—rather than merely
decorative—inset columns, on either side of piers bearing tabernacles.
These are of a new form. They have pilasters tapering towards their
bases, like herms, and bear protrusions that seem to register the oppres-
sive weight of the pediments. The pilasters are partly fluted—but the
familiar classical form is given an unprecedentedly playful treatment as
the flutes fade into the plane surface. Below the paired columns hang
large, complexly-curled volutes that could have no supporting role.
They are witty appendages, seemingly extended from the wall by the
columns' weight. But even more surprising than its individual elements
is the effect of the *ricetto* overall: it is a building turned "outside in"—
indeed, it was developed from the original scheme for the library's
façade, overlooking the piazza of San Lorenzo.

Initially, Michelangelo intended the roof of the *ricetto* to be con-
tinuous with that of the library's reading-room, and lit by a skylight.
When practical objections were raised to the skylight, he changed his
plans radically, adding a second story so that the *ricetto* could be lit by
side windows. Its space now became very high in relation to its floor
area, like the interior of a tower. Contrast replaced continuity, and the
move from the *ricetto* into the low reading room—with its long hori-
zontals, shallow pilasters, slim moldings, subtle changes of wall level
and unemphatic tabernacle windows—became a dramatic enactment
of the soaring effort to acquire knowledge, and the serenity that comes
with its attainment. A third element was never built, yet the small
library planned at the end of the reading room to contain the Medici
collection of Greek codices, would have introduced still another new
drama. This space was to have the most emphatically striking and
arcane floor plan of all—a triangle—and its walls would have been
very deeply articulated.

Michelangelo,
Laurentian
Library
(Reading
Room),
San Lorenzo,
Florence.

Just as the walls of the *ricetto* are treated like architectural façades,
so Michelangelo's re-modeling of the Capitoline Hill* in Rome
(commissioned in the late 1530s), treated the exterior space of the
piazza like the interior of a room. The irregular site featured the high
Palazzo dei Senatori to the east, and the two-story Palazzo dei
Conservatori to the south. Michelangelo laid out the piazza as an
oval, installed the antique equestrian statue of Marcus Aurelius (then
believed to represent the Emperor Constantine) on its axis and
planned an entirely new third palace to the north, exactly mirroring
the Palazzo dei Conservatori. Michelangelo thus fixed the general
layout, but the articulation of the façades of the three palaces was
determined only at the very end of his life. He initially considered
employing small columns to magnify the piazza's spaciousness, but he
finally chose giant pilasters. These reduce the buildings' bulk, give
them a unity, and bring them to life. Michelangelo remodeled the

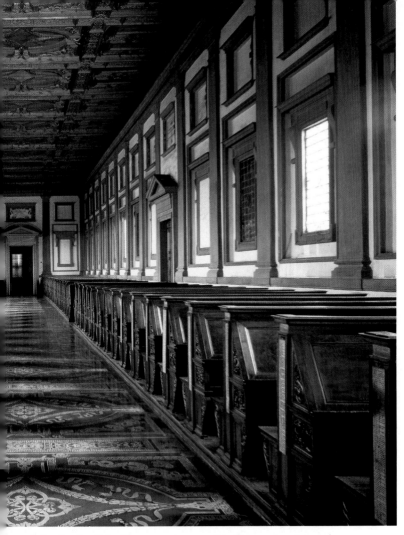

existing loggia of the Conservatori, excavating deep spaces separated from one another by heavy cornices, like rooms grudgingly opened to the exterior. The piazza is effectively transformed into an animated and active interior space, at once commanding and intimate, powerful and protective. Still more remarkably, the great cornices of the flanking palaces are deceptively angled so that the effect is as seen through a wide-angle lens, accelerating the perspective of the piazza and enhancing the importance of the Palazzo dei Senatori. A trick of painting—reminiscent of Bramante's *trompe l'oeil* choir in Santa Maria presso San Satiro in Milan—becomes one of architecture.

The imagination at work is closely akin to that seen at St. Peter's, Rome*, where Michelangelo took over as chief architect after the death of Antonio da Sangallo the Younger in 1546. Sangallo had planned an immense, elongated structure with a long nave and a centrally planned domed martyrium, rising above the high altar. The two parts were

separate, but joined by a narrow "bridge" like the body of an insect. The western end—containing the high altar and hence the liturgical "east"—was to be constructed around the crossing (the area beneath the dome) built by Donato Bramante between 1505 and 1510. Sangallo modeled his exterior, with its successive layers of columns, on the Roman Coliseum. Michelangelo, despising this unimaginative attempt to achieve magnitude through mere multiplication, cut back the scheme ferociously. He eliminated Sangallo's nave and amputated the outer ambulatories of the centralized building, recreating in reduced form the scheme first projected by Bramante in 1505. Unlike Bramante, however, he articulated the exterior with giant pilasters matching those of the crossing inside. Although St. Peter's was not finished according to his plans, Michelangelo's decisions gave the vast building the same tight coherence that characterizes his sculpture. Interior and exterior are united by piers and pilasters, which hold the building together, like the bonds of the *Slaves*. They also transformed the whole church into a fitting martyrium for St. Peter, whose body lies beneath the high altar. Michelangelo continued to modify his designs for St. Peter's until the end of his life, responding to the developing organism as though making a figure drawing; the completed torso allowed a variety of possibilities for the head. His plans for the drum beneath the dome oscillated between horizontal and vertical emphases, and between elevated and rounded silhouettes for the dome itself.

His thoughts about St. Peter's affected, and were affected by, other projects. In 1559–60, he was asked to make designs for three Roman churches, of very different types (see San Giovanni dei Fiorentini and Late Roman Works). San Giovanni dei Fiorentini was to be a new, free-standing church for the Florentine community in Rome. Another was a funeral chapel for the Sforza family, attached to Santa Maria Maggiore. The third was the conversion of the vast central hall of the Baths of Diocletian into a church. In all three cases Michelangelo did the opposite of what any contemporary would have expected.

San Giovanni seemed to call for dramatic façades, but Michelangelo's model, never built, was for a tight, centrally planned church, with a smooth, rounded, minimally articulated exterior, recalling the massive figures and smooth, finely pleated draperies of the Pauline Chapel frescoes. The Sforza Chapel, completed some years after Michelangelo's death in 1564, is small, but has an extraordinarily complex ground plan. Its nucleus is a square bounded by giant columns entirely disproportionate to the size of the building, and which do not support its upper parts: they act rather as masts,

appearing to restrain the billowing walls and tent-like vault. The building seems to be evolving, like one of Michelangelo's sculptures, in response to the winds of divine grace. Irrational from a structural point of view, it is a building that uniquely evokes the parts of faith—permanence, in its columns, and mutability, in its shell.

Finally, at the Baths of Diocletian (now the church of Santa Maria degli Angeli), also completed after his death, Michelangelo took the vast hall not as a nave but as a transept, situating the choir and altar in a small, low chapel midway along its length, facing the low entrance. The worshipper thus advances across—and not along—the hall, approaching the center of faith in the low chapel. In this conversion, Michelangelo created a resonant spiritual poem: the grandeur of the pagan edifice is denied in favor of a humble oratory, a built structure materializing the biblical parable of the "strait gate"—the narrow threshold at which earthly trappings and splendor must be relinquished before entering the kingdom of heaven. For Michelangelo, the building is a metaphorical autobiography, in which the expanse of public life gives way to quietude and silence. Denial becomes an expression of plenitude in his late architecture. Tradition and difference, rationality and paradox fuse for the soul facing eternity. (PJ)

Michelangelo, detail from the *Congregation of the Waters,* 1510. Sistine Chapel, Vatican.

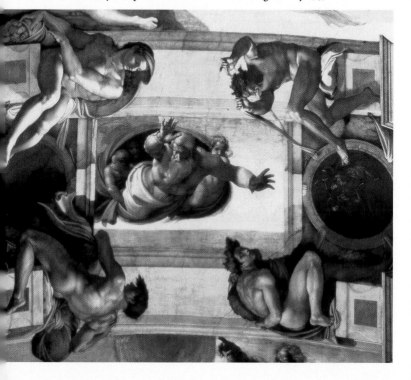

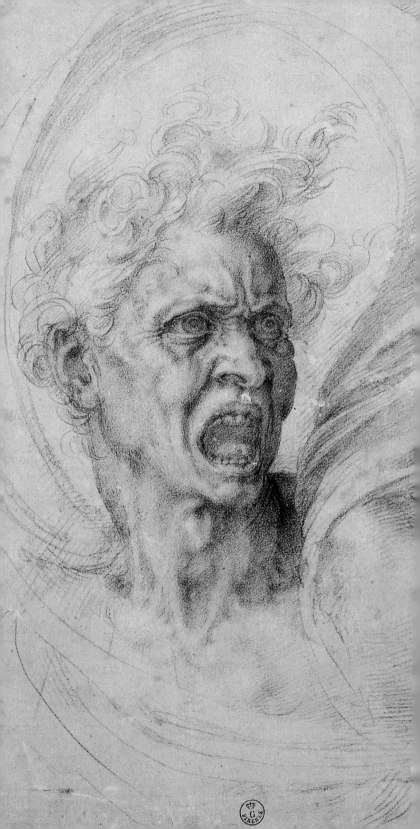

Accademia del Disegno

In May 1562, some twenty years after the founding of the Accademia Fiorentina, Florence's literary academy, Vasari* presented the leading Florentine artists of the day with a plan to establish an academy of art and re-organize the venerable but near-defunct artists' fraternity, the Compagnia di San Luca. Vasari's aims were twofold—first, to create a school devoted to the practical and theoretical training of the most talented young artists; and second, to satisfy both his own and the profession's social and intellectual ambitions by freeing the practice of art as quickly as possible from the constraints imposed by the city's guilds. Cosimo I's patronage was sought and granted, and the official statutes of the new institution were ratified on January 13, 1563. The modern world's first academy of art—the Accademia e Compania dell'Arte del Disegno—was born, with Michelangelo as its proclaimed "*Guida, Padre e Maestro*", and a mission to teach and promote the three so-called *arte del disegno*, namely painting, sculpture and architecture. The vice-presidency of the academy fell to the learned cleric Don Vicenzo Borghini, who immediately set about drawing up erudite schemes for the major artistic programs which it was to oversee, in its role as implementor of the official cultural policy of the Medici. One of the first tasks was the staging of Michelangelo's funeral*, and the execution of his tomb (see Monument to Michelangelo)—an opportunity for the academy to develop its already fast-growing reputation, and to pay a personal homage to its designated spiritual leader. Still more immediately, however, and at Vasari's behest, the academy was to complete the Medici mausoleum in the New Sacristy* of the basilica of San Lorenzo, left unfinished at the time of Michelangelo's death. Since 1536, two generations of aspiring artists had frequented the building, copying Michelangelo's sculptures and architecture. Now, the New Sacristy became known as "the chapel school," synonymous in every sense with the Accademia del Disegno, which officially installed itself from 1563 to 1565, first in order to complete work on the project, and subsequently for want of any other meeting place. The creation of the academy sanctioned the chapel's existing, informal pedagogical role in the name of its "patron saint," Michelangelo. (HS)

Facing page: Michelangelo, *Soul in Damnation* (or the *Fury*), 1520–25. Black chalk, 11⅔ x 8 in. (29.9 x 20.5 cm). Gabinetto Disegni e Stampe, Galleria degli Uffizi, Florence.

Federico Zuccari, *Artists copying Works by Michelangelo in the Medici Chapel at San Lorenzo*, c. 1565. Black and red chalk, 7¾ x 10⅓ in. (20 x 26.4 cm). Musée du Louvre, Paris.

Anatomy

Describing the Christ of the *St. Peter's Pietà**, Vasari wrote that "It would be impossible to find a body showing greater mastery of art and possessing more beautiful members, or a nude with more detail in the muscles, veins

and nerves stretched over their framework of bones, or a more deathly corpse ... the harmony in the joints and attachments of the arms, legs and trunk, and the tracery of pulses and veins are all so wonderful that it staggers belief ..." In Renaissance critical theory, a thorough knowledge of anatomy was one of the sure signs of a great master of the arts, and Vasari was able to point at will to Michelangelo's scientific knowledge of anatomy, evident from his very earliest works and gleaned from his frequent practice of human dissection. Condivi* notes that some time after the death of Lorenzo the Magnificent in 1492, the prior of Santo Spirito in Florence provided Michelangelo "both with a room and with corpses for the study of anatomy ... This was the first time that he applied himself to this study,

and he pursued it as long as he had an opportunity." Condivi later states that Michelangelo finally "gave up dissecting corpses because his long handling of them had so affected his stomach that he could neither eat nor drink salutarily." Unlike Leonardo da Vinci, Michelangelo does not seem to have produced anatomical studies or representations of dissected organs, but a group of drawings of *écorché* figures (from the French for "flayed", showing the body's muscles without skin) dated around 1515–20 (although some may be later), is traditionally attributed to him. We also know, from both Gianotti and Condivi, that Michelangelo was dissatisfied with Albrecht Dürer's *Four Books on Human Proportion*, published in 1528, taking exception to the German artist's focus on "the measurements and varieties of human bodies, for which no fixed rule can be given," and his tendency to form his figures "straight upright like poles." Condivi notes that Michelangelo "had it in mind to write a treatise as a service to all those who want to work in sculpture and painting, on all manner of human movements and appearances, and on the bone structure." Whether due to old age (according to Vasari) or, as Condivi states, because he "doubted his powers and whether they were adequate to treat the subject adequately and in detail, as someone would who was trained in the sciences and in exposition," Michelangelo never wrote the work. Condivi states that Michelangelo showed him "many rare and recondite things, perhaps never before understood" during his dissections, and that he

Michelangelo, *Ecorché* figure study, c. 1520. Pen and brown ink, 11⅔ x 7½ in. (28.3 x 19 cm). Royal collection, Windsor Castle.

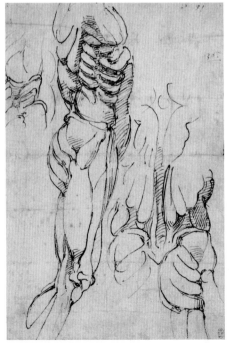

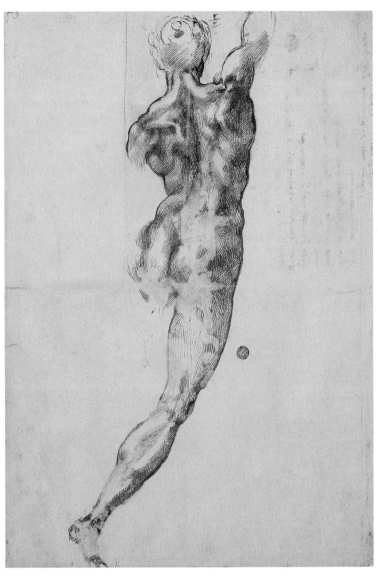

hoped to publish the observations himself one day. The book was never forthcoming, although we know that Condivi did consult with the celebrated anatomist Realdo Colombo, in whose work Michelangelo had shown much interest during his visit to Rome at the behest of Pope Paul III in 1548. In a letter to Duke Cosimo I de' Medici dated April 17, 1548, Colombo announces that his great treatise on anatomy

was to be illustrated by "the foremost painter in the world." The work in question is the *De Re Anatomica*, printing of which began in 1558, but without any plates by Michelangelo. (HS)

▪ Antiquity

Michelangelo's first real engagement with the antique must have occurred during his formative years (from 1489) at the Medici sculpture garden at San Marco*. Condivi* records, probably with

Michelangelo, *Male nude,* c. 1504. Brown ink with traces of black chalk, 16¼ x 11¼ in. (40.9 x 28.5cm). Casa Buonarroti, Florence.

25

an element of embellishment, how Michelangelo taught himself to sculpt at this time by borrowing tools from masons working on the San Marco library in order to copy an antique head of a faun. The distinctly classical *Battle of the Centaurs* * also dates from this time.

By 1496 Michelangelo had carved a *Sleeping Cupid* which had been bought by Cardinal Raffaele Riario on the understanding that it was a genuine antiquity (probably after the Roman, second century A.D. prototype in the Uffizi, Florence). Riaro, nevertheless, discovered the true authorship of the statue and by 1502 it had been acquired by Isabella d'Este. In a letter to her husband she says that the cupid has no equal "for a modern work," illustrating the different status between contemporary and ancient works. Indeed, in 1505 Michelangelo's *Cupid* had been joined in the d'Este collection by a genuine antique work by Praxiteles; such a juxtaposition was no doubt intended to create a form of dialogue between the two figures.

The Ovidian drawings of the 1530s marked the final chapter in Michelangelo's preoccupation with explicitly antique subject matter. The various drawings of the *Fall of Phaeton* demonstrate how Michelangelo adapted classical prototypes to create a paraphrase of antiquity. The version in the British Museum is closest to the text, depicting Phaeton's sisters turning into poplar trees. Visually, it relies heavily on a sarcophagus then outside the church of Santa Maria Aracoeli in Rome. The drawings in the Galleria dell' Accademia in Florence, and the fully-worked sheets in the Royal Collection at Windsor Castle depart significantly from textual and visual sources. Therefore, in comparison with Raphael's archaeological approach to antiquity, Michelangelo would often change the meaning of those images he appropriated. The *Battle of the Centaurs** for example, is an early example of an interpretation of classical antecedents. Similarly, in a drawing of the *Labours of Hercules* (Royal Library, Windsor) the central group has been derived from an antique prototype depicting Hercules slaying the lion, but whilst the classical profile has been retained the meaning has changed—he now struggles with Antaeus. The group on the right, which depicts the slaying of the hydra, demonstrates the indelible impact of the rediscovery of the antique *Laocoon* group in 1506 (Vasari* states that Michelangelo witnessed its excavation). The rhythm of the three images on the sheet is in itself reminiscent of sarcophagus types depicting the Labours of Hercules.

The influence of the antique is also clearly discernible in the *Last Judgement* * (begun in 1536). The head of Christ resembles the *Apollo Belvedere*, most notably the fact that he is beardless, a feature that was subsequently criticised by clerics and theologians. Michelangelo's extraordinary empathy with antique art remained with him until the 1540s, when he adopted more elongated, sparsely modeled forms, as exemplified in the *Rondanini Pietà**. (AB)

▮ Architectural Models

Like all architects of his time, Michelangelo presented his designs to his patrons by means of accurate wooden models,

often based on initial "sketches" in clay. Two such models have come down to us: one showing the façade of San Lorenzo in Florence, the other the dome of St. Peter's* in Rome. Other models are known through pictures. A painting by Domenico Passignano shows the artist submitting a model of St. Peter's to the Pope (1619, Casa Buonarroti, Florence); an engraving by the French architect Le Mercier shows a model made for the Roman church of San Giovanni dei Fiorentini*, and another picture (in the Casa Buonarroti) by Fabrizio Boschi shows Michelangelo presenting a palace façade to the Pope, possibly a commission from Julius III for the Mausoleum of Augustus. Many other models were made, now known only through written descriptions.

The model for the façade of San Lorenzo*, made following Michelangelo's instructions in 1516 by the joiner Baccio d'Agnolo, shows only one of the unfinished project's numerous design stages. With a façade-cum-narthex, the design is inspired by Alberti's church of Sant'Andrea in Mantua, but differs from the latter in its use of two stories separated by an intermediary level, prefiguring many late sixteenth-century buildings, and the strongly modeled profiles of its cornices. In the model, the unadorned façade is completely devoid of the numerous reliefs and free-standing statues which it was clearly designed to hold. As such, it is an important reminder of Michelangelo's initial concept of the function of architecture, as a kind of pictorial frame for sculpture, and provides a striking contrast to his later work both at San Lorenzo and elsewhere (see Knowledge, Difference, Paradox). (HS)

Baccio d' Agnolo. Wooden model for the façade of San Lorenzo from a design by Michelangelo, 7 ft. x 9 ft. 3⅓ in. x 19⅔ in. (216 x 283 x 50 cm). Casa Buonarroti, Florence.

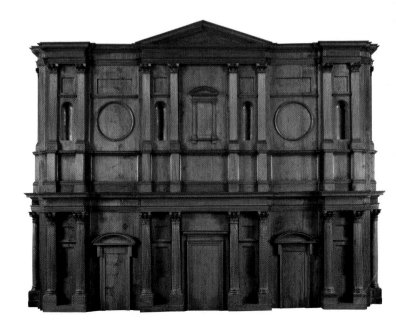

▓ ARCHITECTURE

Michelangelo had no particular vocation for architecture, yet his architectural work is highly significant, and proved enormously influential. Indeed, Michelangelo seems to have had architecture "thrust upon him:" the discipline is inherent in his earliest commissions from Julius II—the latter's monumental tomb attained the proportions of a building in its own right. And the decoration of the vault of the Sistine Chapel* is set within a painted architectural framework. Michelangelo's first truly architectural projects were in Florence, however, in the 1520s: the façade, the New Sacristy* and the Laurentian Library* at the "Medici church" of San Lorenzo, as well as the city's fortifications (see Siege of Florence). Upon his return to Rome under Paul III, he was put in charge of a number of major works—the Farnese Palace*, the new basilica of St. Peter's*, the remodeling of the Capitoline Hill*, the creation of the church of Santa Maria degli Angeli within the antique Baths of Diocletian (see San Giovanni dei' Fiorentini and Later Roman Works), the Porta Pia*.

All of these projects, including the work in Florence, had one notable feature in common—none of the buildings were *a nuovo*, or completely new. In each case Michelangelo had to work in the context of existing structures—Brunelleschi's basilica and Old Sacristy at San Lorenzo, Giuliano da Sangallo's unfinished building site at St. Peter's, the Roman Baths of Diocletian. Far from inhibiting his creative powers, Michelangelo seems to have found inspiration in the constant challenge posed by such constraints. Michelangelo the sculptor tackled the strictures of his chosen block of stone, and Michelangelo the architect affirmed his genius by overcoming the technical limitations and challenges set by his predecessors, to achieve a triumphantly new and original vision.

Michelangelo's architectural artistry is everywhere apparent: from his visionary designs for difficult, monumental projects that enabled him to rival the great structures of ancient Rome, to his endlessly imaginative ornamental details, constantly re-inventing or abandoning the classical Vitruvian canon in the pursuit of new forms.

Michelangelo's impact on architectural history is considerable—from his "direct descendants" in late sixteenth-century Florence (Vasari, Buontalenti, Ammannati) to the generation of "Baroque" architects born around 1600. It is worth remembering that Bernini, Borromini, and Pietro da Cortona would have seen Michelangelo's late designs being built during their childhood and early training. For them, St. Peter's and the remodeled Capitoline Hill (in particular) were not relics from an earlier age, but the architectural avant-garde of their time. (FL/YP)

Michelangelo, sketch of construction plan for San Giovanni dei Fiorentini church, c. 1559–62. Black chalk, 5 x 6¾ in. (13 x 17 cm). Casa Buonarroti, Florence.

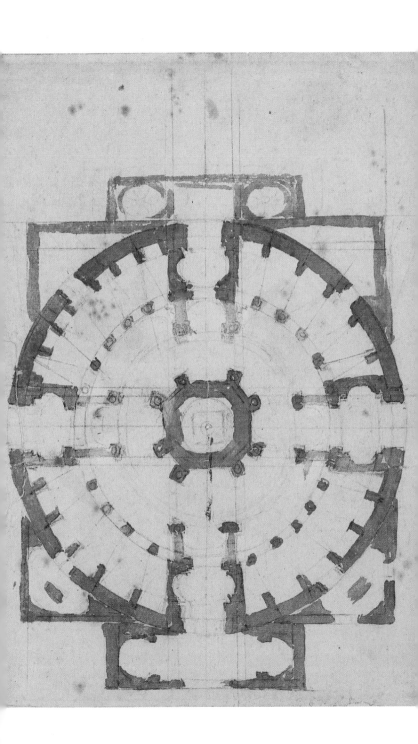

29

■ ARETINO, PIETRO
An "open letter" to Michelangelo

"Sir, Upon viewing your *Judgement* in its entirety, I truly believed that in the beguiling beauty of its invention, I had rediscovered the grace of the illustrious Raphael. As a Christian, however, I was shocked by the shameful liberties—so offensive to the soul—which you have taken in your expression of the most fundamental elements and aspirations of our true faith. Thus, … the esteemed Michelangelo has chosen to demonstrate to the world a degree of religious impiety matched only by the perfection of his art. Is it possible that you, whose 'divine' condition causes you to disdain the company of men, could have committed this sin … in the greatest chapel in Christendom … you show us angels and saints, the latter with no mortal decency and the former bereft of their celestial attributes … your depiction of martyrs and virgins is an indecent spectacle indeed, and the gesture with which [one of the damned] is seized by the genitals would be enough to cause the viewer to lower his eyes in shame if it were painted on the wall of a brothel. Your work is fit for a Turkish bath, not a majestic choir … our souls want the heat of

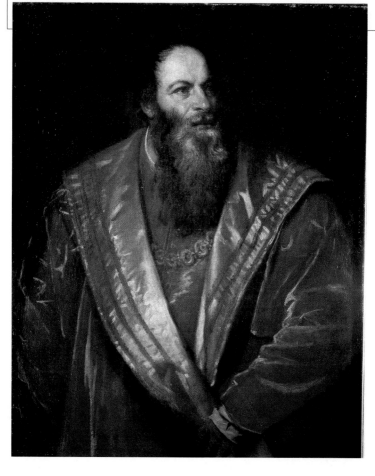

piety more than the vigor of your drawings, hence I pray that God may inspire His Holiness Paul [Paul III] … to begin to erase from Rome such proud, idolatrous ornaments, before—by their very quality—they prove deleterious to the respect and humility which are proper to representations of the saints." Pietro Aretino addressed this letter to Michelangelo from Venice in November 1545. But in 1544, he had given a quite different account of the fresco of the *Last Judgement** (which he knew only from copies): "at the sight of your terrifying … *Day of Judgement* [sic] my eyes were flooded with tears of unbridled emotion. Think, then, what tears I should have cried, before the work of your own, sacred hands?" Was this change of heart an expression of purely literary indignation conditioned by the religious climate of the time (see Censorship and Evangelism)? Or a bitter outburst born of long-harbored resentment? Certainly Aretino, better known for his licentious sonnets and wilfully obscene dialogues than for his religious writings, aspired nonetheless to be made a cardinal. But it is also true that despite his frequent solicitations (since 1538), Michelangelo had never granted him the gift of an original drawing. Neither did he respond to this virulent epistolary attack, which was published in 1550 in the fourth volume of the Aretino's *Letters*, no longer addressed directly to Michelangelo, but in the guise of a letter to Alessandro Corvino. (HS)

ASSISTANTS
The solitude of Michelangelo: myth and reality

Vasari cultivates Michelangelo's image as a solitary, superhuman genius allowing no one to be at his side while he was working; but he also stresses his moral qualities, and particularly the great generosity which he often showed to members of his entourage, always ready to help one or other of his followers and associates by providing them with working drawings for their own projects. Vasari also names the sculptors who were brought in to expedite work on the Medici* tombs and that of Pope Julius II*; he mentions the Florentine Tiberio Calcagni as Michelangelo's assistant in his declining years, helping the elderly master with his architectural schemes. In reality, Michelangelo was clearly no stranger to the organization and functioning of a studio of collaborators, as demonstrated by his capable direction of construction work at St. Peter's. The cleaning of the Sistine Chapel vault* has also given the lie to Vasari's claim that Michelangelo quickly fired the assistants brought with him from Florence, in order to work on the frescoes alone. In fact, the assistants left in autumn 1509, and their contributions are clearly identifiable, not only in the decorative elements and roundels, but also in the biblical scenes, particularly the *Flood*. Michelangelo retained tight control of his assistants' work down to the last detail, however, providing the designs and exact specifications.

Clearly, then, Michelangelo did have both temporary assistants and longer-term disciples; but he had few pupils in the formal sense, and none of any great talent. The "mysterious" Pietro d'Argenta was a member of his entourage during Michelangelo's first stay in Rome; he is sometimes identified as the painter of a number of works attributed to the "Master of the *Manchester Madonna*" (see *Manchester Madonna*). The others were Pietro Urbano, Antonio Mini (who left for France with the *Leda** and some of his master's drawings), and Condivi*. Michelangelo cherished his independence, and never sought to establish a traditional *bottega*, or to surround himself with a court of brilliant pupils and collaborators in the manner of, for example, Raphael. (HS)

■ Bacchus

A series of bookkeeping records enables us to date the carving of the *Bacchus* to between July 1496 and July 1497, during the first year of Michelangelo's first stay in Rome (1496–1501). From these same documents, it appears that the work was commissioned by none other than the Cardinal of San Giorgio, Raffaele Riario, who Michelangelo had duped into buying the *Sleeping Cupid* as a genuine antique statue (see Antiquity). It is clear, however, that Riario was displeased by the *Bacchus*: by 1506, the statue was already in the home of Jacopo Galli, the Roman banker and collector, and an important mentor for the young Michelangelo. There can be no doubt that the group was intended for display out of doors; it was seen first in the *cortile*, and later among the population of antique statues, in the gardens of the Casa Galli, where it naturally invited comparisons between modern and antique statuary. The composition is clearly designed to encourage the spectator to walk around it: the little satyr, counterpoint to the figure of Bacchus, and the tiger skin pressed against Bacchus' leg, remain hidden if the group is viewed from the front.

The young god's staggering pose, indicative of his drunken state, is particularly daring. According to Francisco de Holanda*, Michelangelo executed the *Bacchus* with the aim of "misleading the Romans and the pope, by passing it off as an antique." But even if one was momentarily fooled by "the color of the marble, or the design," the work, as Holanda quite rightly pointed out, could only be modern, as witnessed by the "the uncontrolled, unbalanced movement and positioning of Bacchus's legs— quite alien to the Ancients." The *Bacchus* also inspired fine commentaries by Condivi* and Vasari*, the former stressing "the mirthful face and sidelong lascivious eyes" of the drunken young god; the latter, "… the slenderness of a youth combined with the fullness and roundness of the female form." It was pointed out that the surface of the group was treated with varying degrees of finish. Bacchus's hair, for example, is not worked with the same care and virtuosity as the garland of vine leaves and bunches of grapes. Drill holes are also visible, especially in the figure of the satyr, and the tiger's head. (HS)

*"Neither painting nor sculpture will be able
any longer to calm my soul,
now turned toward that divine love
that opened his arms upon the cross to take us in."*

Sonnet sent to Vasari in a letter of September 1554,
trans. Saslow.

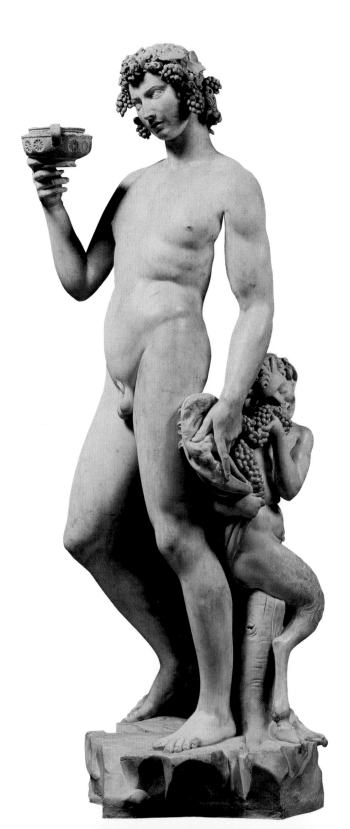

■ BATTLE OF CASCINA
Michelangelo pitted against Leonardo da Vinci

In 1503 Florence's governing body, the Signoria, commissioned Leonardo da Vinci to paint a fresco on one wall of the Sala del Maggior Consiglio (the Great Council Chamber) in the Palazzo Vecchio (then, as now, the city hall). The painting was to depict the Battle of Anghiari, a glorious episode of Florentine history dating back to 1440. The following year, Michelangelo was commissioned to paint another wall of the chamber with a depiction of the Battle of Cascina, Florence's historic victory of 1364 over the armies of neighboring Pisa. Neither artist completed this vast undertaking. Da Vinci abandoned his fresco after carrying out unsuccessful technical trials; Michelangelo's work never progressed beyond the full-size cartoon* (now lost) made in order to transfer his composition onto the wall. "Michelangelo in his cartoon exhibited a considerable body of infantry," wrote Benvenuto Cellini in his *Memoirs*, published in 1728, "who were bathing in summer-time in the river Arno; at this very instant he represents an alarm of battle, and all the naked soldiers rushing to arms with gestures so admirably expressive that no ancient or modern performance was ever known to attain so high a degree of perfection". In complete contrast to da Vinci's furious mêlée of soldiers on horseback, Michelangelo took a more narrative approach, including the aforementioned depiction of soldiers dressing in haste for combat. Recent research suggests that he may have taken an account of the battle in Leonardo Bruni's *Historia Florentini Populi* as his source; clearly, the scene has undeniable appeal as an ideal vehicle with which to demonstrate his mastery of the nude, and his magisterial knowledge of anatomy* (Vasari* notes the figures' "incredible postures").

Copies of the cartoon would seem to confirm Vasari's description, which relates that Michelangelo's original composition also featured "countless more [soldiers] dashing to the fray on horseback". The group of bathers—now known to us only through the grisaille copy by Aristotele da Sangallo—may therefore have been conceived by Michelangelo as the main element in a larger overall scheme. The cartoon was completed in spring 1505, when Michelangelo was summoned urgently to Rome by Pope Julius II*. Finally exhibited in the Palazzo Medici, the cartoon was broken up by 1516, and the fragments dispersed. But while it remained intact it was, in Cellini's words: "the school of the world", endlessly studied and copied. (HS)

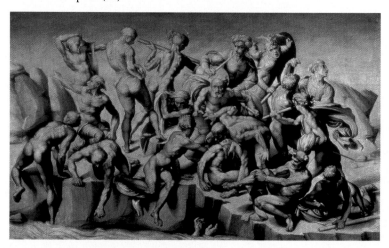

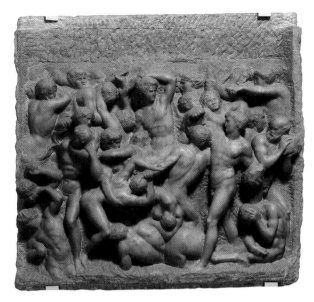

Michelangelo, *Battle of the Centaurs*, 1491–92. Marble, 31⅔ x 34⅔ in. (80.5 x 88 cm). Casa Buonarroti, Florence.

■ Battle of the Centaurs

This relief is one of Michelangelo's earliest surviving works, probably executed when he was only seventeen years old. It is the only narrative relief in his sculpted oeuvre and one that he repeatedly refused to sell. The subject matter derives from Ovid's *Metamorphoses* (XII, 210–535) where at the wedding of Pirithous and Hippodamia (the offspring of a centaur) the centaurs became drunk and attempted to rape both bride and female guests. A ferocious battle between the Lapiths (relatives of Pirithous) and centaurs ensued. According to Condivi*, Michelangelo did not read the text himself, but was fed the story by Angelo Poliziano, a philologist and poet who had been entrusted with the education of Lorenzo de' Medici's heirs.

The roughly hewn area at the top of the relief suggests that the work is incomplete, possibly interrupted by the death of Lorenzo in 1492, although the lack of finish in the background figures serves an artistic purpose in conveying a diminishing of outline caused by perspective.

The image is an intensely personal evocation of the subject matter, quite unlike anything produced in Florence at that time. Amongst the complex, interlocking mass of nude figures it is impossible to distinguish between the anthropomorphic centaurs and their human counterparts. The story, therefore, has been ignored in favor of an intense study of energy and movement; this sense of emotion conveyed through physical action was probably inspired by Antonine sarcophagi. A bronze relief depicting a battle by Bertoldo di Giovanni (Bargello, Florence), who was probably in charge of the sculptors at San Marco, was also based on this sarcophagus type, but whereas Bertoldo's figures are modeled almost in the round, Michelangelo's emerge and subside into the marble with an effortless fluidity. The similarity between the two works suggests that Condivi's portrayal of Michelangelo as an autodidact is probably mythographical, and Bertoldo (according to the Vasarian tradition) probably played some form of educational role in Michelangelo's early years. (AB)

Facing page: Aristotele da Sangallo (after the cartoon by Michelangelo), *The Battle of Cascina*, 1542. Grisaille. Collection of the Earl of Leicester, Holkham Hall, Norfolk.

> *"To what does the power of a fair face spur me?*
> *There's nothing on earth that gives me joy, except*
> *to rise, still alive, among the blessed spirits*
> *through a grace so great no other can compare."*

Michelangelo, sonnet no. 279, trans. Saslow.

▓ Beauty

Ideal beauty or form was a concept much debated by philosophers and theorists of the fifteenth and sixteenth centuries. Savonarola* propounded a definition of beauty based on the writings of Aristotle, "a form which results from the correspondence of all members and colours," whereas Neoplatonists* were more preoccupied with a notion of spiritual beauty. Michelangelo certainly subscribed to both concepts, although his Neoplatonic thinking is usually given more emphasis. For him, the "Ideal" was clearly expressed not only in Neoplatonic philosphical writings, but also in the proportions and sentiment of antique, classical works of art, which were a driving force behind his own canon of perfection. His own works draw on the classical canon and Neoplatonic concepts of the Ideal in a specifically Christian context—hence the "twin" notions of a purely aesthetic quest for Ideal beauty, and the concept of beauteous form as a manifestation of Judeo-Christian divine grace. Certainly, the equation of beauty with Good or Wisdom is a basic, loose translation of Neoplatonic ideas which might have appealed to Michelangelo, and which is described in some of his poetry*. The potential muddling of the Ideal, the divine and, simply, the "perfectly executed" or "marvelous" in his work, is neatly illustrated by Michelangelo's series of fantastical, antiquizing presentation drawings for Gherardo Perini and others—the head studies referred to by Vasari as "*teste divini*" (see Divine Heads*), despite the fact that they are not clearly identifiable as saints or biblical characters. With their sometimes distorted, grimacing features, not all of them qualify as manifestations of Ideal beauty in the Neoplatonic sense, either (although some of them do). In this specific context, Vasari probably did not intend the word "*divini*" in the religious sense; elsewhere, however, his repeated references to Michelangelo as "*il divino*" clearly imply that his talents are God given. In both cases, Vasari's English translator, George Bull, renders the word "*divino*" as "inspired," and this seems to encapsulate quite successfully the triple strands of Christian divine grace, Neoplatonic Ideal beauty and form, and sheer "marvelousness" that are everywhere apparent in Michelangelo's work. (AB)

▓ Bologna

Michelangelo's life was punctuated by hasty departures—not to say flights—from one city to another, spurred by disagreements with his patrons or political troubles that threatened his safety. In October 1494 he fled north from Florence, alarmed (according to Condivi*) by the

premonitions of "a certain man nicknamed Cardiere" regarding the imminent fall of the Medici. (Piero de' Medici was indeed driven out of Florence by followers of the religious fanatic Savonarola* on November 9, 1494; on Novermber 17, Savonarola consolidated his support by ne-gotiating with the French King Charles VIII—at the head of a huge army on its way to conquer the kingdom of Naples—thereby saving Florence from occupation and sack). After a brief stay in Venice, Michelangelo spent a year in Bologna as the guest of Giovan Francesco Aldrovandi, who delighted in his readings of Dante, Petrarch and Boccaccio. Their encounter was not, perhaps, as accidental as Condivi suggests: Aldrovandi—a man of culture, and the trusted confidant of Bologna's leader Giovanni Il Bentivoglio—had been a *podestà,* a city magistrate, in Florence under Lorenzo de' Medici in 1488, and may well have learned of his future protégé's exceptional talents at this time. In Bologna, he arranged for Michelangelo to finish the decorative sculpture on the tomb (the *arca*) of St. Dominic. As successor to the recently deceased Niccolò dell'Arca (so-called for his work on the tomb), Michelangelo executed three of the four missing statuettes: *St. Proculus* (its expression closely prefiguring that of the *David**), *St. Petronius,* and a classically inspired *Kneeling Angel* holding a candlestick, the latter conceived as a pendant and critical response to Niccolò's existing figure. As these three widely differing statuettes show, Michelangelo's stay in Bologna

was far more than an isolated episode in his early years, and did much to broaden his artistic horizons. Much is often made of his contact here with the work of Jacopo della Quercia (1374–1438), the Sienese sculptor who carved the massive panels flanking the west door of Bologna's cathedral, San Petronio. But above all, it is the sharp, incisive pictorial vocabulary of the great Ferrarese painters (Cosimo Tura,

Michelangelo, *St. Proculus,* 1494–95. Marble, h. 23 in. (58.5 cm). San Domenico, Bologna.

Francesco del Cossa and Ercole de' Roberti) that seems to have inspired the sculptural tour de force seen in the drapery of the figure of *St. Petronius*, "an early expression of the Mannerist crisis in Classicism" (Andrea Emiliani).

Michelangelo returned to Bologna in November 1506, where he was reconciled with Pope Julius II*, who had recently entered the city at the head of the armies of the Papal States. Julius commissioned Michelangelo to produce an bigger than life-size bronze effigy of himself for the façade of San Petronio. Installed in 1508, the statue was "thrown to the ground and destroyed in the fury of the populace" (Condivi) in 1511, when the Bentivoglio family regained power. (HS)

■ Bruges Madonna

Mentioned by Condivi and Vasari among the works produced by Michelangelo during his stay in Florence from 1501–05 (albeit incorrectly—both speak of a work in bronze, and Vasari describes a tondo), the *Bruges Madonna* was carved for the Mouscron family—Flemish cloth merchants active in Rome, referred to in the source documents as the "Moscheroni." Since little is known of Michel-angelo's activities in Rome between the summer of 1499 and the autumn of 1500, and given that his links with the Mouscron family are documented from 1498, it has recently been suggested that the commission may date from this period. In any event, the two known documents relating to payment for the *Bruges Madonna* date from December 1503 and October 1504, both recording that Michelangelo received the sum of 100 ducats. In August 1505, the statue was due to be crated for transportation, but this did not finally take place until the following year. A letter to Michelangelo (then in Florence) from the Roman banker Balducci, dated August 14, 1506, relates how the Madonna was to be sent to Flanders: "to Bruges, to the heirs of Jan and Alexander Mouscron", who were to install it in the family chapel in the collegiate church of Notre-Dame. The work did not remain long in Florence, and was seen by few, as apparently indicated in Michelangelo's letter to his father, dated January 1506, asking him to "have the statue taken to his house, and to show it to no one." The work finds an echo in a work by Raphael, however—the Child of the so-called *Belle Jardinière* (Musée du Louvre, Paris), painted towards the end of the latter's Florentine period, in 1507 or 1508. Later, drawings of the statue were a primary source for the Virgin and Child in Parmigianino's celebrated *Vision of St. Jerome* (National Gallery, London). Formally, the *Bruges Madonna* represents a completely new departure. The Child, whose twisting body contrasts with the Virgin's perfect stillness and frontality, is no longer sitting on her knees, as tradition dictated, but standing up between her legs; holding his mother's hand for protection, he is about to take one uncertain step, on his path of destiny. Michelangelo here presents the theme of the Virgin as a "stairway" by which the Son of God descends to earthly life for the salvation of mankind—a central theme in Michelangelo's work, as seen in the *Madonna of the Stairs**. (HS)

Michelangelo, *Bruges Madonna*, 1503–05. Marble, h. 37 in. (94 cm) with base. Church of Notre-Dame (Onze-Lieve-Vrouwekerk), Bruges.

■ CAPITOLINE HILL

In 1538, Pope Paul III commissioned Michelangelo to create a piazza on the Capitoline Hill in Rome, with the antique equestrian statue of Marcus Aurelius—then kept at the Palazzo del Laterano—as its center-piece (no other square in Rome was judged fit to receive it). The Capitol, seat of the ancient Arx and the ultimate symbol of Roman civic power, was a difficult, uneven site, bordered to the north by a hill crowned by the church Santa Maria Aracoeli. The Palazzo dei Senatori, a medieval building on the site of the ancient Tabularium, was bordered to the south by the more recent Palazzo dei Conservatori (early fifteenth century). Seeking a solution incorporating the two existing buildings, which were not at right angles, Michelangelo created a trapezoidal piazza with the oval base of the statue of Marcus Aurelius marking its center point. The oval form of the statue's base is echoed in the star motif on the slightly convex pavement, no doubt intended to recall a military shield, the emblem of the Caesars. New façades were planned for the palaces. The Palazzo dei Senatori was provided with a rusticated basement, sur-mounted by two stories rhythmically articulated by monumental Corinthian pilasters. Two symmetrical flights of stairs, set against the basement, rise to meet at the palace's entrance, framing a pair of river-gods (still *in situ*) on either side of a niche housing a statue of Jupiter. The Palazzo dei Conserva-tori was given a covered, flat-vaulted ground-floor loggia. Here, Michelan-gelo's use of colossal pilasters, and the play of surfaces and deep spaces,

bring a sense of unity to the façade: pillars and (at the sides) Ionic columns framed the loggia's openings— immense shadowy caverns concealing the offices within. An identical build-ing (the Palazzo Nuovo) was planned for the other side. Begun in 1603, it was not completed until about 1650–60. Michelangelo, the quintes-sential Florentine architect, succeeded in transforming the Roman Capitol into a unified, harmonious ensemble, incor-porating monuments and buildings

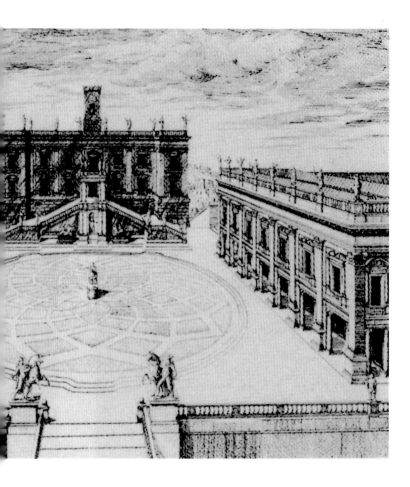

alike. The unprecedented use of ovoid forms for the base for the central monument and the surrounding pavement enabled Michelangelo to centralize the space on an axis marked by the Palazzo dei Senatori, facing the sloping approach to the square. The ensemble's dynamic conception, in which vertical and horizontal forces are held in (sometimes tenuous) balance was a source of wonder for Bernini, who witnessed the completion of the Palazzo Nuovo. (FL/YP)

Etienne Dupérac, *The Capitoline Hill, Rome,* 1569. Engraving, 16⅔ x 22⅓ in. (42.2 x 56.5 cm). Vatican Museum, Rome.

▪ CARTOON: A tool of the trade and a work of art

Originally a technical device for sizing up sketches to the scale of the finished work, in the hands of Michelangelo and da Vinci the cartoon became a work of art in its own right, a source of pride for its creator, and a prized (and ultimately collectable) object whose public display was a major cultural event. Made from large squares of paper pasted together, the cartoon enables a painter to enlarge an initial working drawing square by square, for transfer onto a large panel or wall. In his treatise *On Technique*, Vasari notes that "… the man who found out such an invention had a good notion, since in the cartoons one sees the effect of the work as a whole, and these can be

adjusted and altered until they are right, which cannot be done on the work itself." His praise for Michelangelo's cartoon of the *Battle of Cascina** is unstinting. With it, he notes, the cartoon becomes not only a work of art but a veritable school of art, too: "after the cartoon had been finished and, to the glory of Michelangelo, carried to the Sala del Papa, with tremendous acclamations from all the artists, those who subsequently studied it and made copies of the figures … became excellent painters themselves." Vasari describes the lost cartoon's various drawing techniques in detail, noting that Michelangelo used the work as an opportunity to "show how much he knew about his craft."

Other cartoons by Michelangelo, also lost, became the source of numerous copies and finished versions painted by other artists. This is true of the *Leda**, which Vasari says was brought back from France to Florence by Benvenuto Cellini, and two cartoons subsequently painted by Pontormo*—especially the *Venus and Cupid*, for which a secondary cartoon exists in the Museo di Capodimonte in Naples, generally no longer regarded as being by Michelangelo.

In reality, only two of Michelangelo's cartoons have survived. The first is a fragment showing a section of the Pauline Chapel's* *Crucifixion of St. Peter* (also in the Museo di Capodimonte), measuring 8 ft. 7.5 in. x 5 ft. 1.4 in. (263 x 156 cm), which was apparently used as the basis for a series of secondary cartoons using a technique which had the merit of preserving the original cartoon, unlike the usual methods of direct transfer (*spolvero*—"pouncing" charcoal dust through pinpricks in the paper—or heavy tracing with a metal stylus). The other cartoon, at the British Museum, London, is the drawing known as *Epifania*, which Michelangelo made for Condivi*. Vasari notes scornfully of his rival, "Ascanio spent years on a picture for which Michelangelo provided the cartoon, and all in all, the higher expectations he aroused have gone up in smoke." Condivi's unfinished picture is now in the Casa Buonarroti in Florence.

The drawing is one of four large cartoons recorded in the inventory of Michelangelo's studio, made on the day after his death. (HS)

▪ Cavalieri, Tommaso de'

Tommaso de' Cavalieri (c. 1512–87) was a member of the Orsini Cavalieri family. His marriage to Lavinia della Valle in 1545 united two prominent Roman dynasties. His private and public life are relatively undocumented, but contemporary accounts describe him as a figure of "incomparable physical beauty" (Varchi*), gifted with the highest personal qualities. Drawn to art and the antique, he dabbled in painting and was

already well-known as a man of culture and character when he met Michelangelo in late autumn 1532. His exact date of birth is unknown, but he was probably about 20 years old. On New Year's Day 1533, Michelangelo, then aged 57, wrote the first of many letters to Cavalieri, confessing himself to have been "completely over-whelmed" by the young man. The friendship between the two proved lasting and intimate, but for Michelangelo it was also a towering passion—one that probably influenced his final decision to leave Florence for Rome in September 1534, and whose intensity lives on undimmed in the poems that Cavalieri inspired. Its true nature is of course alluded to in the celebrated series of drawings that Michelangelo made for Cavalieri early in their relation-ship, as described by Vasari*: the *Rape of Ganymede* (the version in the Fogg Art Museum in Cambridge, Massachusetts, is now generally recognized as the original), the pendants showing the *Punishment of Tityus* (Royal Collection, Windsor Castle) and the *Fall of Phaeton* (the drawing in the Royal Collection, Wind-sor Castle, is the most finished of the three extant versions), and the mysterious *Infant Bacchanalia* (also at Windsor). These ambitious drawings, which were immediately acclaimed and much copied in a variety of media, have all been interpreted as expressing *amor platonicus*. Vasari also notes that "to show Tommaso how to draw," Michelangelo gave him a series of "breathtaking drawings of superb heads" (see Divine Heads), and that he made a life-sized portrait of the young man (now lost).

Their friendship survived the jealous attacks of numerous detractors. Aretino's* open etter to Michelangelo refers to the latter's refusal to grant him a gift of a drawing, comment-ing bitterly, "only certain Gherardos and Tommasos can obtain them". In November 1548, Cavalieri was appointed *deputato speciale alla fabbrica del Campidoglio,* or superinten-dent in charge of works on the Capitoline Hill. After Michelangelo's death, Cavalieri oversaw the faithful implemen-tation of his friend's designs for the Palazzo dei Conservatori and the Palazzo dei Senatori. With Daniele da Volterra*, he was at Michelangelo's bedside when he died. (HS)

Facing page: Michelangelo, *Epifania*, c. 1550. 25 assembled sheets. Black chalk, 7 ft. 7⅓ in. x 5 ft. 5 in. (2.32 x 1.65 m). British Museum, London.

Michelangelo, *Infant Bacchanalia*, 1533, red chalk, 10 ¾ x 15 ⅓ in. (27.4 x 38.8 cm). Royal Collection, Windsor Castle.

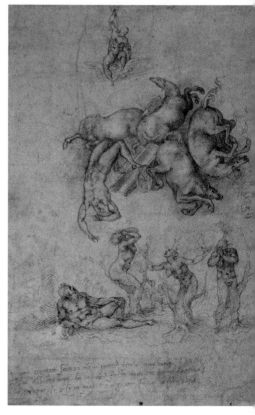

■ CENSORSHIP
The Last Judgement in peril

Aretino's* "open letter" to Michelangelo is dated November 1545. On December 13 of the same year, the long-awaited ecclesiastical "Council of Trent" was assembled in Trento. Convened in the face of the rise of Protestantism, and to answer the many accusations leveled at Rome by Protestant "dissidents," the Council concluded almost twenty years later (1563) with the approval, among numerous other reforms, of a decree on the "Invocation, Veneration, and Relics of Saints, and on Sacred Images"—a clear indication of Rome's desire to regulate and control the images placed in Catholic churches: "no images [suggestive] of false doctrine, and furnishing occasion of dangerous error to the uneducated, [should] be set up ... all lasciviousness [should] be avoided; in such wise that figures shall not be painted or adorned with a beauty exciting to lust.... In fine, let so great care and diligence be used herein by bishops, as that there be nothing seen that is disorderly, or that is unbecomingly or confusedly arranged, nothing that is profane, nothing indecorous, seeing that holiness becometh the house of God." In other words, by calling for decency, "truth," and accuracy in the depiction of religious subjects, the text sanctioned the criticisms aimed at the *Last Judgement** since 1541.

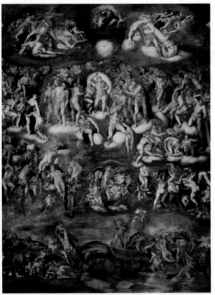

In the eyes of the uncompromising advocates of the Counter-Reformation, the fresco did indeed depict shameful nudity and ambivalent attitudes, above the high altar of the pope himself. It also overturned the orthodox iconography. Michelangelo was sharply reproached for the impropriety of his Christ, represented without a beard, and standing rather than seated on the throne of glory described in the gospels; his Virgin, who does not intercede on behalf of the souls about to be judged; his halo-less saints; and his wingless angels, tumbling about like acrobats.

The presence of Charon, the ferryman who bore the souls of the dead across the river Styx in classical legend, was considered equally inappropriate, despite its function here as an allusion to Dante's description of Hell, in the *Divine Comedy*. The cleric Gilio da Fabriano (1564) stressed that poetry and theology should not be confused; his dialogue *Degli Errori de' Pittori* ("On the Errors and Abuses of Painters") set out to show exactly how sacred images should be depicted.

The fresco survived a very serious threat of destruction, already mooted in Aretino's open letter. But in January 1564, after deliberations by the council ratified by Pope Pius IV (1559–65), a commission decided that the nudes should be discreetly veiled. The task fell to Daniele da Volterra*, and others subsequently—the job was not finished until at least the end of the seventeenth century. (HS)

Colonna, Vittoria

From one of Italy's noblest families, Vittoria Colonna (1490–1547) at seventeen married Francesco d'Avalos (1489–1525), Marquis of Pescara. D'Avalos was the architect of the papal armies' imperial victory at Pavia in 1525, but died soon after. Vittoria never re-married, and instead devoted herself to poetry and religion, spending time at her castle at Ischia and on retreat at several convents (notably in Rome and Viterbo), where she encountered several so-called "evangelical" advocates of ecclesiastical reform. She was a close friend of Cardinal Reginald Pole, who favored a compromise between Rome and the Protestants, and took as her confessor the brilliant Capucin preacher Bernardino Ochino, who introduced her to the ideas of Valdès. Threatened by the Inquisition (which was revived under Paul III in 1542), she subsequently broke with these "dangerous" friends. Colonna's poems, published in 1538, were an immediate success, with no less than fourteen editions between 1540 and 1560. But it was her persona—as much as her poetry—that earned her the admiration of the leading minds of her day. To Michelangelo, whom she met probably around 1536, she was indeed a superior being—the incarnation of Beauty, Intelligence, and Truth, a muse capable of interceding between himself and the Heavens, "You make me rise, my lady / so far above myself / that I can't express, or even / imagine it, for I'm no longer myself." In the poems which Colonna inspired, Michelangelo evokes the symbol of a block of marble: just as

Cristoforo dell'Altimissimo, *Portait of Vittoria Colonna*. Galleria degli Uffizi, Florence.

the sculptor is capable of freeing his forms from the mass, of breathing life into stone, so Vittoria's virtue and spiritual rigor are capable of delivering him from his rough-hewn state: "at birth I was a model / of little worth / to be reborn through you, / noble and worthy lady, as a noble and perfect thing. / … your grace builds up what I lack, and files down / my excess." Michelangelo describes himself toiling up "the long, steep road" to salvation, and begs Vittoria to "descend to where I can reach you."

Their exalted friendship expressed itself in other ways, too, notably in a joint campaign for spiritual renewal in their time. Michelangelo's own spiritual "conversion" owes much to Vittoria and her circle, all of whom sought a truer, more authentic faith and a "purer" Church. Both believed in the doctrine of justification through faith (or, in the case of Christ, through the grace of God) rather than the "mechanical" accomplishment of good works—a central theme in Paul's Epistles which (according to dialogues written by the Portuguese painter Francisco de Holanda*) they read together at San Silvestro. Their spiritual relationship is most profoundly expressed in the drawings

Facing page: Marcello Venusti, *Copy of Michelangelo's* Last Judgement *before the intervention of Daniele da Volterra,* 1549. Tempera on panel, 6 ft. 2 in. x 4 ft. 9 in. (1.88 x 1.45 m). Museo Nazionale di Capodimonte, Naples.

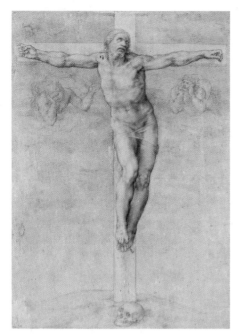

Michelangelo's "kindred spirit," the only woman to have played a prominent and acknowledged role in his life—and this when he was on the threshold of old age—died in 1547. "On account of her death," wrote Condivi*, "he remained a long time in despair and as if out of his mind". (HS)

■ Color

The greatest surprise of the cleaning of the Sistine Chapel vault* (1980–89) was without undoubtedly the revelation of Michelangelo as a bold colorist, employing iridescent hues and striking chromatic dissonance, the more so since neither Vasari* nor Condivi* refer to this aspect of the work. In fact, the revelation was more of a rediscovery—late nineteenth-century commentators such as Charles Blanc had already noted that "it is insufficiently acknowledged that Michelangelo, that prodigious draftsman, was also a colorist, who used color like light."

The Sistine's "rediscovered" colors are anticipated in Michelangelo's work by the *Doni Tondo*. They play a specific role in the context of the chapel as a whole, enhancing the fresco's legibility for viewers below.

Michelangelo, *Holy Family,* known as *Il Silenzio*, c. 1540. Drawing. Collection of the Duke of Portland, London.

which Michelangelo made for his divine muse, and which she then elaborated upon in sonnets or letters: a *Crucifixion* (British Museum, London), a *Pietà* (Isabella Stewart Gardner Museum, Boston), a *Christ and the Woman of Samaria* (lost)—all of which stressed the role of women in spiritual dialogue—and, perhaps, the drawing known as *Il Silenzio* (Collection of the Duke of Portland, London). All were the subject of numerous painted copies (see Venusti), and were widely disseminated as engravings.

Michelangelo, detail of the Sistine Chapel vault: segment above the lunette of *Roboam and Abiah.*

46

As already seen in the *Manchester Madonna** and the *Doni Tondo*, Michelangelo uses color as a supplementary tool to construct form. His use of *cangiante* (strongly contrasting colors that articulate the "change" from shade to light) not only contributes to the rich tonal range of his paintings, but is designed to enhance their plasticity and to convey a sense of volume. The technique is not Michelangelo's own—its use was already evident elsewhere in the Sistine Chapel, in the late quattrocento frescoes on the walls. Without Michelangelo's vault, however, the unreal, dazzling palettes and early Mannerist forms of Pontormo*, Rosso or Beccafumi would have been unthinkable. (HS)

Ascanio Condivi, *Vita di Michelangelo Buonarroti*, Rome, 1553. Bibliothèque Nationale de France, Paris.

■ Condivi, Ascanio

Born in the Italian province of Marche, Condivi—a modestly accomplished painter and a devoted disciple of Michelangelo—is now known solely thanks to his book, *The Life of Michelangelo*, published in Rome in 1553. Then aged 78, Michelangelo may well have instigated the biography, using Condivi (who had asked to be taken on as his pupil) as the supposedly objective author of what was, in reality, a deliberate piece of myth-making. In any event, the work is a clear response to Vasari's* account of Michelangelo published three years earlier, in the first edition of the *Lives*. In an implicit jibe at his rival, Condivi states that he intends to correct the errors and fill the gaps in earlier portrayals of the artist's life, and hopes above all to be a "diligent and faithful" collector of Michelangelo's recollections and observations, which he has taken down "skillfully and with long patience from the living oracle of his speech."

In fact, Condivi's account contains errors of its own, and much escapes him when it comes to interpreting the works of his adored master. But his biography remains an essential resource for all students of Michelangelo, containing much information (particularly on the artist's family origins and early years), which Vasari was forced to take into account when revising his own text for the second edition of the *Lives* in 1568. The success and renown of Vasari quickly eclipsed that of Condivi, however, albeit undeservedly. Despite its hagiographic and apologetic qualities, Condivi's account is infinitely more moving than Vasari's, imbuing Michelangelo with greater humanity and heroism. Michelangelo the man emerges as a complex artist tortured by bitter public humiliations, private doubts and denials.

Condivi announced his intention to publish other documents in his possession relating to Michelangelo, as well as the latter's poems, which he had collected, but nothing further appeared during his lifetime. He left Rome for his native town of Ripatransone, near Ascoli Piceno, in 1554. (HS)

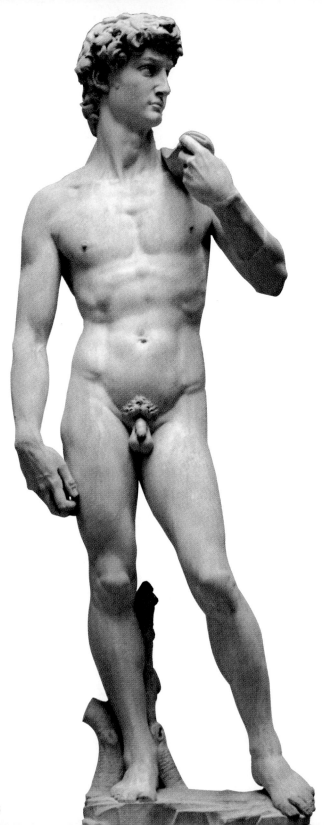

■ DAVID

Michelangelo returned to Florence from Rome in March 1501, evidently with the aim of securing the gigantic block of marble from which he would carve the *David*, the first colossal nude statue since ancient times. He doubtless also hoped to succeed where Agostino di Duccio (1463–64) and Antonio Rossellino (in 1476) had failed, in the attempt to carve a *gigante*, a "giant," destined for one of the buttresses of the Duomo (Florence's cathedral, Santa Maria del Fiore). The contract, dated August 16, 1501, was issued by the wool merchants' guild, the *Arte della Lana*, and the cathedral authorities (the Opera dell' Duomo, who owned the marble block), and stipulates that Michelangelo must deliver the work within two years. On January 25, 1504, the cathedral authorities convened a commission of illustrious Florentine painters and sculptors (including Leonardo da Vinci and Botticelli), to decide on a site for the *David*, which was practically finished. On June 8, 1504, the statue was installed in front of the Palazzo Vecchio, Florence's city hall, replacing Donatello's *Judith* as the symbol of republican government. The decision seems to have been in keeping with Michelangelo's wishes: his *David* was conceived as an exaltation of civic virtues, identified by Charles de Tolnay as Strength—through its blend of the biblical and antique heroes David and Hercules, the mythical protector of Florence—and Anger, in the sense of intolerance to the mindless exertion of power through brute force. The notion of the defense of republican freedoms is implicit in Michelangelo's representation of the young shepherd, not triumphant with Goliath's head at his feet, but at the moment when he first defies his giant adversary and prepares to do combat, with his sling as his only weapon. David's pose is confident, suffused with power, and his gaze is proud beneath his angry frown. Michelangelo clearly felt a degree of pride, too, having taken on a "giant" of his own. A note on a working drawing for the statue, now in the Louvre, reads, "David with his sling, and I with my bow" (meaning both his arrow-like perspicacity, and his sculptor's trepan or drill). His great technical achievement was in working solely from the original marble block, which had been "badly roughed-out" by his predecessors, with no extra pieces added. Like the *St. Peter's Pietà**, the *David* was carved from a single block, and was thus the equal of the great masterpieces of antiquity. (HS)

Michelangelo, *David*, 1501–04.
Marble, h. 13 ft. 5⅓ in. (4.10 m).
Galleria dell'Accademia, Florence.

◼ Del Piombo, Sebastiano

Sebastiano Luciano (c. 1485–1547) became known as Sebastiano del Piombo when Clement VII appointed him Keeper of the Papal Seals (the seals were made of lead). A pupil or collaborator of Giorgone's, he was already an artist of some repute in his native Venice when banker Agostino Chigi brought him to Rome in 1511. First inspired by Raphael, with whom he worked at the Farnese Palace, he later became a follower of Michelangelo, who supported him by providing designs for a number of important commissions: the *Pietà* finished in 1516 for the church of San Francesco in Viterbe (now in the Museo Civico at Viterbe); the decoration of the Borgherini Chapel at San Pietro in Montorio in Rome (c. 1516–34; and the *Raising of Lazarus* (National Gallery, London) painted in competition with Raphael's *Transfiguration*. After Raphael's death in 1520, Sebastiano became known as the foremost painter in Rome, and an unrivalled master of portraiture.

His friendship with Michelangelo, then exiled from Rome, is documented in numerous letters exchanged between 1516 and August 1533. In December 1533, Sebastiano was at work on the so-called *Ubeda Pietà*, for which he had again solicited Michelangelo's help. The work was the final fruit of their long collaboration, which was marred from 1535 onwards by disagreements and misunderstandings over the *Last Judgment* *. Sebastiano, who successfully experimanted with oils in the *Flagellation* at San Pietro in Montorio, suggested that Michelangelo use the technique. Michelangelo remained undecided, says Vasari*, until he finally declared that "oil painting is for women, old men and lazy good-for-nothings like Fra Sebastiano," and that fresco was his sole medium of choice. Sebastiano's spoilt, lazy character (which also features in Holanda's* Roman dialogues), is central to Vasari's account: his appointment to the sinecured post of Keeper of the Papal Seals in 1531 apparently made him lazy and profligate with his newfound income. In fact, Sebastiano continued to work—but at his customary slow pace, to the extent of leaving certain commissions unfinished. As André Chastel has noted, the artist seems to have suffered a serious spiritual crisis following the Sack of Rome, as expressed in the works he painted subsequently, both in their raw, dark quality and their choice of subject-matter, centered on the Passion (notably, the *Ubeda Pietà* and the three versions of *Christ bearing the Cross* now in Madrid, St. Petersburg and Budapest). (HS)

Sebastiano del Piombo, *Pietà*, 1516. Oil on panel. Museo Civico, Viterbe.

Michelangelo,
Bust of a Female Figure in profile with a Child and an Old Man (Zenobia?),
1520–25.
Black chalk,
14 x 9⅞ in.
(35.7 x 25.2 cm).
Gabinetto Disegni e Stampe, Galleria degli Uffizi, Florence.

■ Divine Heads

The expression comes from Vasari*, who describes how Michelangelo drew a series of *"teste divine"* in the early 1520s for Gherardo Perini, and later for Tommaso de' Cavalieri*, in order to "show Tommaso how to draw". The "divine heads" form one of the series of "presentation drawings" made by Michelangelo for his close friends (see Drawing). There are a great many of them, and their authenticity has regularly been called into question. Their meaning and significance for Michelangelo is also unclear. Mostly female, sometimes accompanied by more roughly-sketched figures, they are generally seen in profile, as was common in contemporary portraits that revisited the forms of antique medals. Inevitably, one of the heads (in the British Museum, London) has been tentatively identified as Vittoria Colonna*, but the rest are not portraits in the true sense of the term (Vasari notes that Michelangelo disdained to make likenesses, unless his sitter "was of infinite beauty"). Similarly, most of the heads cannot be clearly identified as biblical, mythological or historical figures. One may represent *Cleopatra* (Casa Buonarroti, Florence), and another *Zenobia* (Uffizi, Florence), and it has been suggested that Michelangelo was planning to put together a "gallery" of powerful heroines, inspired by Boccaccio's *De Claris Mulieribus*. In any event, the series is remarkable for its expressive range, from ideal beauty to a

51

marked fascination for facial deformities and contortions—as in the *Soul in Damnation*, also known as the *Fury* (Uffizi, Florence), which is clearly influenced by Leonardo da Vinci's explorations of the emotions and their physiognomical expression, as seen in his studies of combatants for the *Battle of Anghiari* (see *Battle of Cascina*).

Despite being conceived as a private gift, Michelangelo's *Divine Heads* quickly became part of the figurative vocabulary of their day. Artists were especially fascinated by the elaborate coiffures worn by many of the women. As such, they are the direct artistic ancestors of the elaborately coiffed heroines of Mannerism. (HS)

■ Dolce, Lodovico

Lodovico Dolce (1508–68), earned his living as a copyist with the printer Giolito in Venice. Published by the latter in 1557, his *Dialogo della pittura,intitolato l'Aretina* ("*A dialogue of painting, in the guise of Pietro Aretino*") is generally regarded as his best written work. It is particularly important for the study of contemporary artistic theory in Venice, as the first published Venetian reply to Vasari's* *Lives* (1550)—and a harsh reply at that. In the guise of the dialogue's chief protagonist, Pietro Aretino*, Dolce challenges Vasari's Tuscan and Florentine bias, and goes on to contest the title of "absolute master" conferred by him upon Michelangelo. The main aim of the treatise is to demolish Vasari's view of art history, holding up Raphael as a counter-example to Michelangelo and precursor of the ultimately exalted Titian. His comments are in large part

directed at the fresco of the *Last Judgment**, which serves to illustrate his polemic. Michelangelo is attacked in the name of "honesty," "conformity" and "acceptability." His conceits are too complex ("none but the most learned are capable of understanding the depth of his allegories"), forcing him to paint "ridiculous" subjects. In the very chapel of the pope himself, his figures—as "perfect as they are unwholesome"—would in no way incite the viewer to piety and religious devotion. Michelangelo's art is also said to be lacking in variety ("when one has seen one figure by Michelangelo, one has seen them all') overly "difficult" and affected in its technique ("foreshortening incites admiration and astonishment in proportion to the restraint with which it is used"). In a clear declaration against the "Michelangelists" and Mannerism in general, the author levels the same criticisms at the output of the would-be "new Michelangelos"—muscular nudes "in preposterous, inappropriate attitudes." Raphael, on the other hand, stands for universality, appropriateness, variety and *sprezzatura* (facility of execution, or the impression of it—"that most difficult of attainments, the art of concealing art"). Refusing to sacrifice his artistic beliefs on the altar of Michelangelo's flourishing cult, Dolce propounds another, with an equally bright future—that of Raphael. For his part, Titian, praised unreservedly for his naturalism, is hailed as the painter who succeeds most admirably in reconciling "the grandeur and *terribilità* of Michelangelo, the charm and beauty of Raphael, and the colors of Nature herself." (HS)

■ Doni Tondo

The *Doni Tondo* is the only surviving documented panel painting by Michelangelo. It also retains its original frame, which was probably designed by the artist himself and which incorporates the interlocking figures of Agnolo Doni and Maddalena Strozzi. It is probable, therefore, that the painting commemorates either their marriage in 1504 or the birth of their heir in 1507. An image representing the Virgin and Joseph as emblems of Christian marriage and parental care would have assumed a certain relevance on both occasions.

The smooth brushwork, lucid color and extreme emphasis on *disegno* are stylistic attributes typical of turn of the century Florence. The extreme torsion and complex interlocking of figures was, however, ground-breaking in its departure from prototypes in the tradition of Leonardo da Vinci. The meaning of this complex expression of movement is unclear, as is the relevance of the frieze-like backdrop of nude figures (a similar device can be found in tondi by Luca Signorelli). It has been suggested by Charles de Tolnay that they represent the pagan era which has been superseded by that of grace (through Christ)—hence the separation of foreground and background by the parapet. The figure of John the Baptist, who looks up at the Holy Family, is considered

Michelangelo, *Doni Tondo*, 1504–07. Tempera and oil on panel, Galleria degli Uffizi, Florence.

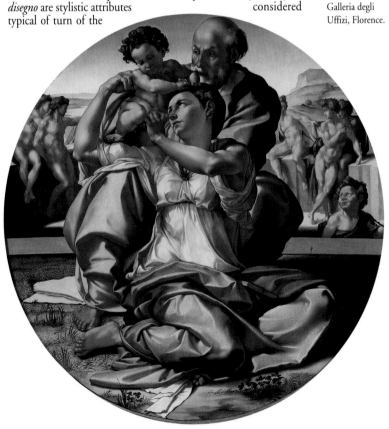

53

to represent the era of Law (ushered in by Moses) or an intermediary epoch. This reading is purely speculative, but perhaps lent credence by the presence of sibyls and prophets on the frame, who announce the coming of Christ to pagan and Jewish worlds respectively.

The typically Michelangelesque, muscular form of the Virgin is tempered by the grace of her action and softness of expression. The tension in space created by the dynamic interaction of gaze between Virgin and Child perhaps prefigures the same quality created by the almost touching fingers in the *Creation of Adam* (Sistine Chapel vault*). (AB)

Drawing

Michelangelo was a tireless draftsman, a habit no doubt instilled during his formative years in Ghirlandaio's workshop. Here he would have learnt the importance of drawing in the creative process and the Florentine emphasis on *disegno*. Surviving works demonstrate he embraced various different media, chosen according to the function of the image. Black chalk, embellished with wash, seems to dominate in the later works, worked to an emotive, atmospheric effect.

In Dolce's* *Dialogo* Michelangelo's graphic ability is described by Raphael, through the mouthpiece of Aretino, as a

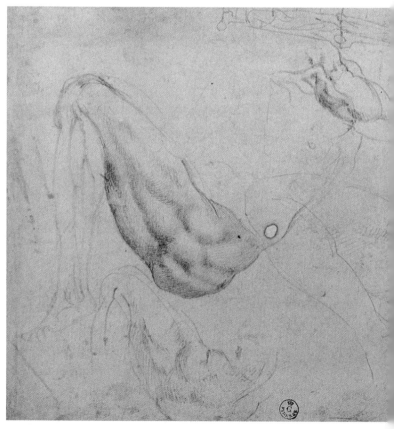

Michelangelo,
*Nude study
(three thigh studies
for the figure of*
Night *on the
tomb of Giuliano
de' Medici*),
c. 1526–31.
Black chalk
on paper.
Galleria degli
Uffizi,
Florence.

"rare miracle of art:" indeed, after 1537, Aretino is known to have made repeated attempts to obtain his drawings. Whilst Michelangelo sometimes used drawings as gifts for friends and superiors, he also occasionally adopted artistic personalities and is known to have provided studies for both Sebastiano del Piombo* and Daniele da Volterra* as visual aids.

Presentation drawings executed for Tommaso de' Cavalieri* and Vittoria Colonna (such as the *Fall of Phaeton* and *Bacchanal of Children*, both in the Royal Library, Windsor) were highly finished works of art in their own right. The level of detail has in the past led some scholars to question their authenticity, although this is now generally accepted. Surviving works suggest that Michelangelo tended to draw with specific projects in mind, rather than using them as an outlet for investigative thought in the manner of Leonardo da Vinci. They were also produced as demonstration pieces for patrons, as the high level of finish of drawings for door surrounds in the Casa Buonarroti suggest. With some frequency, images are juxtaposed with the written word (for example *Anatomical Drawings* in the British Museum, London), although the relationship between the two is often complex. Although drawings survive from various stages of completion (from sketch to cartoon), only a fragment of Michelangelo's output survives. According to Vasari* he wilfully destroyed numerous sheets at the end of his life. This was, to some extent, to maintain the façade of *spezzatura,* the ability to create with ease, and to hide the process of development. (AB)

■ Evangelism

Italy was far from untouched by the Protestant Reformation. Luther's writings were circulated there as early as 1519, first in Latin and then (in part) translated into Italian. In general, however, the Lutheran movement was known only in certain élite circles where it attracted a number of followers before being quickly subsumed into the broad current of "evangelism" as a whole.

Influenced by the humanism of Erasmus and other new ideologies, the evangelists preached a Christianity "of the spirit," based on the emulation of Christ, and proclaimed the pre-eminence of faith over a show of good works. The movement's most important work was the *Trattato utilissimo del beneficio di Gesù Cristo crocificco verso i cristiani* (Venice, c. 1540–43), a small almanac which enjoyed great success before being thrown onto the Inquisition's bonfire of heretical books. It has been identified largely as the work of two followers of Juan de Valdès (1509?–41): Fra Benedetto da Mantova and Marco Antonio Flaminio. Condemned by the Spanish Inquisition for his Lutheran-inspired *Dialogo de doctrina cristiano* (Alcala, 1529), Valdès took refuge in Naples in 1532. He was a notable influence on the renowned preachers Pietro Martire Vermigli and Bernardino Ochio (particularly regarding the dogma of justification through faith, which was central to his thinking), as well as the Florentine Pietro Carnesecchi, who was burned at the stake for heresy in 1567. Questioned in 1566, the latter provided his interrogators (and posterity) with valuable

information on the evangelical movement in Italy, and especially the activities of Vittoria Colonna*, in whom an "attitude of compromise" was observed, following "the advice of Cardinal Reginald Pole, that she should apply herself to the exercise of faith as if this were the sole means by which she might be saved, and to the carrying out of good works, as if the salvation of her soul depended on it". The Diet of Ratisbon in 1541 squandered a golden opportunity to re-establish Christian unity. In 1542, Pope Paul II was incited by Cardinal Carafa to revive the Roman Inquisition throughout Italy, spelling the end of the Italian Reformation. Some, such as Ochino and Vermigli, chose exile rather than death at the stake, and quickly fled to Switzerland. Others took refuge in Nicodemism—the outward adherence to the liturgy of the established Church while professing in one's heart the only "true faith" (in reference to the Pharisee and prominent Jewish religious leader Nicodemus, who consulted with Christ in secret, at night, according to John's Gospel). This was an increasingly widespread practice in the wake of the Italian Counter-Reformation, after 1550. Interestingly, the central male figure supporting the dead Christ in Michelangelo's *Pietà* for the Duomo in Florence—often cited as a self-portrait—is sometimes identified as Nicodemus. (HS)

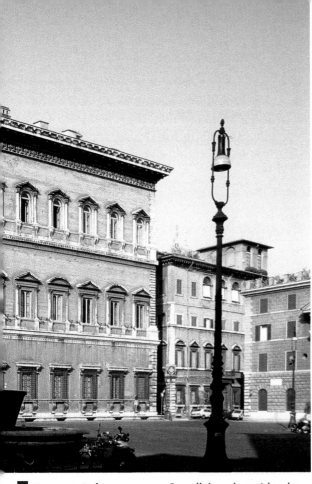

Farnese Palace,
main façade,
Rome.

■ Farnese Palace

The residence of Cardinal Alessandro Farnese was begun around 1515 by Antonio da Sangallo* the Younger. In 1546, the year of Sangallo's death, work was already well advanced and the Cardinal, now Pope Paul III, commissioned Michelangelo to carry it through to completion. Vasari* claims (probably incorrectly) that the two architects were pitted against each other in a competition for the upper cornice of the street façade. Michelangelo's classical cornice, comparable to those seen on the great Florentine palaces, featured a vigorous design, which was violently criticized. He re-worked the central bay of the *piano nobile*, replacing

Sangallo's arches with a long, rectangular entablature supported by two load-bearing walls. He also designed the highly original arms at the top of the bay. Michelangelo's contribution is more clearly apparent in the central courtyard, of which Sangallo completed only the ground and lower first floors. Michelangelo finished the first floor in a restrained style, retaining the arches designed by his predecessor, with the exception of those in the side wings, which he closed up (all of the arches were walled up in the nineteenth century). He brought the full range of his creative genius to bear on the last story, however, which is totally unrelated to the rest. Here, Sangallo's arches have

gone, and his textbook Vitruvian ornamentation is replaced by a highly original "composite" order of Michelangelo's own invention. Michelangelo made slight modifications to the palace's interior (raising the galleries of the *piano nobile*), but there was no time to carry out his grandiose overall plan to open up the two lower stories of the back wing, with galleries overlooking the gardens and (beyond the Tiber) the Villa Farnesina. The building was finally completed in 1589, under Vignole and Giacomo della Porta. (FL/YP)

■ FUNERAL: "Thus might art exalt art"

Michelangelo died in Rome on February 18, 1564. His body was returned to Florence at the behest of Duke Cosimo I, who planned to pay homage to the great master, with the greatest possible pomp and ceremony. Spurred on by its vice-president, and by Vasari in particular, the Accademia del Disegno* agreed to oversee the preparations down to the last detail, fixing the venue for the solemnities (the Medici church of San Lorenzo) and the date (July 14, 1564), commissioning Benedetto Varchi to write and deliver the funeral oration, and mobilizing a sizeable team of young artists to

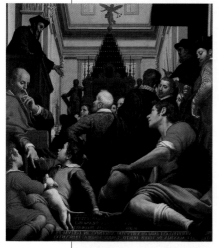

produce the decorations. Ingenuity was the keyword, so that art might honor art; the centerpiece was the vast catafalque erected in the middle of the basilica, draped in black, from which rose a pyramidal obelisk some 52 ft. 5.9 in. (16 m) high, supporting a soaring allegorical figure of *Fame*. The whole structure was decorated with monochrome paintings and imitation marble sculpture, evoking Michelangelo's life and "virtues", on the sides and corners of the two lower registers. The obelisk featured two portrait medallions of the artist, with personifications of the arts— Architecture, Painting, Sculpture, and Poetry—seated around its foot. Scenery installed along the length of the nave was equally inventive and grand in scale—a succession of large painted tableaux to the glory of Michelangelo, his patrons and protectors, leading from the entrance to the high altar, each with an accompanying poetic inscription. Figures and other emblems of death were distributed throughout the side-chapels, and were a remarkable testimony—according to Vasari—to the imaginative powers of the artists engaged on the project.

The event was, in other words, as much a triumph for Michelangelo as for the Accademia del Disegno, which subsequently oversaw the publication of a description of the ceremonies and the funeral oration, anxious to preserve the splendid ephemera for posterity. (HS)

Facing page:
Agostino
Ciampelli,
*Michelangelo's
Funeral
Celebrations*,
c. 1613–35.
Casa Buonarroti,
Florence.

Ottavio Vannini,
*Lorenzo the
Magnificent
surrounded by
Artists, including
Michelangelo, in
the Garden of San
Marco*, 1635.
Palazzo Pitti
(Sala da San
Giovanni),
Florence.

Garden of San Marco

Condivi* describes the garden of San Marco as an informal setting for teaching and study; at various points in his second edition of the *Lives* (1568), however, Vasari* refers to them quite specifically as an "academy" headed by the sculptor Bertoldo di Giovanni (c. 1440–91), appointed by Lorenzo the Magnificent "to create a school for the training of painters and sculptors of the highest quality." Four years earlier, the program printed for Michelangelo's funeral presented the gardens in the same light: as Florence's first school of art, and whose greatest glory was to have counted Michelangelo among its pupils. Vasari's account has its detractors, notably the French art historian André Chastel, who regards it as pure invention, designed to create a precedent for the Accademia del Disegno* and to propound an idealized vision of a Laurentian golden age. Recent research would seem to support Vasari's version, however—the garden clearly existed and played an important role in Florentine cultural life at the end of the quattrocento, not only as an open-air museum (and an essential stop on the city's tourist trail), but also as a "workshop" where events and parades were planned and prepared.

The *giardino* (in fact a *casino* with a loggia opening onto the garden) was located at the corner of Piazza San Marco and what is today the Via degli Arizzieri. It was already in existence in 1475 (when the young Leonardo da Vinci would have been able to visit it), and contained (probably secondary) pieces of antique sculpture from Medici collections (the most important and best-preserved items being housed in the Palazzo Medici on Via Larga), as well as cartoons and drawings by contemporary masters, which were made available to

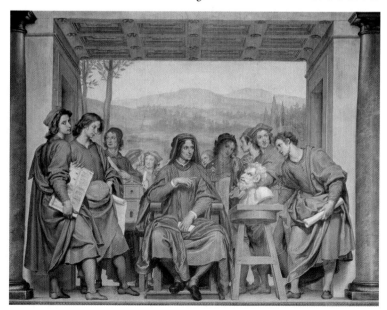

the young artists authorized to work and study there, all of whom (according to Vasari), were "more or less" dependent on Lorenzo's generosity for their upkeep. This was certainly true of Michelangelo, who frequented both the garden and Lorenzo's circle from around 1489–90, when he became a member of Lorenzo's household. At the gardens, he probably studied alongside the painters Francesco Granacci (his great friend) and Niccolò Soggi, and the sculptors Pietro Torrigiano (traditionally responsible for Michelangelo's broken nose) and Andrea Sansovino. In October 1494, a letter describing his flight to Venice notes that he still "*ischultore dal giardino*", which would seem to indicate that the garden continued to fulfil its pedagogical role after Lorenzo's death (on April 18, 1492). It is possible that Michelangelo may have carved his first large-scale marble statue here, from 1492–94 (the *Hercules*, now lost); the statue may have been a Medici commission, later installed in the palace gardens at Fontainebleau by the French King François I. (HS)

■ Giannoti, Donato

A man of letters, the author of a significant body of political and literary works, Donato Giannoti (1492–1573) was one of a number of pro-republican Florentine exiles forced to flee the city when the Medici returned to power following the fall of the Florentine republic. Unlike some, including Varchi* who later rejoined the Medici camp, he never gave up the cause. During the last years of the Florentine republic (1527–30), he was elected first secretary to the magistrature known as the

Dieci di Balia. Banished by the Medici upon their return to Florence, he turned to writing, expounding his hopes for peace and his republican ideals—based on the Venetian model—in treatises such as *Della Repubblica Fiorentina* (written between 1530 and 1535, but first published in 1721). From 1539–50, he worked in the service of the anti-Medici Cardinal Niccolò Ridolfi (1501–50), whom he persuaded to buy Michelangelo's bust of *Brutus* (only the head was by Michelangelo; the draped bust was by the artist's assistant, Tiberio Calcagni). The work was loaded with political significance—by referring to a famous classical episode of tyrannicide, it glorified the new Brutus, Lorenzo de' Medici, who had assassinated Duke Alessandro de' Medici on the night of January 6, 1537. Condivi* describes Lorenzo's victim as "fierce and vengeful." Giannoti, in his *Dialoghi ... de'giorni che Dante consumò nel cercare l'Inferno e il Purgatorio* (Rome, 1546) says that "... with one voice, men celebrated, honored, exalted those who, to free their country, would assassinate tyrants." The dialogues reproach Dante for his condemnation of Caesar's assassin's in the *Divine Comedy*; they also feature Michelangelo, in conversation with another of Gianotti's close friends, the author Luigi del Riccio. The artist emerges as an admirer of Dante, who remains convinced nonetheless that "he who kills a tyrant, does not kill a man, but a wild beast in human form." Giannoti died in Rome, where he worked on a collected edition of Michelangelo's poetry*, abandoned in 1546. (HS)

Michelangelo, *Brutus*, variously dated from 1540–48. Marble, h. 29 in. (74 cm). Museo Nazionale del Bargello, Florence.

■ Holanda, Francisco de

Francisco de Holanda (1517–84) was born in Lisbon and studied under the celebrated humanist André de Resende. His father, Antonio, taught him manuscript illumination. He traveled to Italy at a young age, as part of the retinue of the Portuguese ambassador to the Vatican, and arrived in Rome in 1538 where, unforgettably, he met Michelangelo. When he left Italy in March 1540, he had traveled the length and breadth of the peninsula, devoting his spare moments to the study of its monuments and works of art. Holanda's drawings of his Italian "grand tour" were collected in a volume entitled *Antigualhas* (now in the Escorial Library, Madrid); his dazzling impressions of the journey doubtless influenced the work he planned to write upon his return to Portugal—*Da Pintura Antigua* (completed in 1548, but never published), which has been described as the first Neoplatonic treatise on painting. His *Four Dialogues on Painting in the City of Rome* form the second part of the treatise. Their authenticity is much-contested, but their defenders point out that Francisco was undoubtedly closer to Michelangelo during his two years in Rome, than Vasari was throughout his life. The dialogues are supposed to have taken place in October and November 1538, among members of Vittoria Colonna's* circle at San Silvestro al Quirinale.

Francisco de Holanda, *Michael Angelus Pictor* (*Antigualhas*, f. 2r). Escorial Library, Madrid.

Besides Colonna herself, the other participants are Michelangelo, Francisco de Holanda and other Roman friends. The protagonists discuss, among other things, the power and function of painting, and its price: Michelangelo is reported as stating that a picture's value should never be calculated simply in terms of the number of hours an artist has spent upon it, but also in terms of its quality, and the scope of the artist's learning. In the first dialogue, Holanda's Michelangelo gives vent to his celebrated, if harsh, opinions on Flemish painting, while eulogizing the Italian school. The former, in Michelangelo's eyes, is nothing more than a profusion of details assembled "without art" or reason; the only "true painting", he maintains, is Italian: "none other than the copy of God's perfection, and the reminiscence of his creation; a music that the intellect alone may strive to hear."

Holanda's discussions with Michelangelo on various aspects of art are reported in the long-overlooked first volume of the *Dialogues*, dealing with art theory. Here, we find an exposition of Michelangelo's theory of the value of *despejo* or "reduction", as opposed to "overloading" with detail. Holanda states that this concept was of the highest importance to Michelangelo, who never ceased to "hammer it home". Holanda ranks *despejo* in second place after the all-important "Idea"* in his *Table of the Precepts of Painting*. (HS)

Michelangelo, *Awakening Slave*, between 1518 and 1530. Marble, h. 8 ft. 9 in. (2.67 m) (including base). Galleria dell' Accademia, Florence.

▮ Idea

Plato's notion of the *idea*—in English translated as Idea—or form, was appropriated and transmuted by sixteenth-century theorists who used it, in some part, to elevate the status of the artist and method of artistic production. The Idea was a metaphysical facet of perfection pre-existent in the mind which the artist would attempt to recreate in his work. During the sixteenth century this was often bound with an Aristotelian or empirical approach which drew upon Zeuxis' example (cited in Pliny's *Natural History*) of selecting disparate parts to create a single image of perfection. It was a fusion of these principles on which Raphael based his notion of a *certe idea*. It is, however, the more Platonic method of creativity that scholars often associate with Michelangelo.

In Dolce's* *Aretino* the term is used by Raphael, through the mouthpiece of Aretino, to express Michelangelo's ability as a draftsman. Conversely we find that Michelangelo does not at any time use the word himself. We are hindered by the lack of any formal theoretical discussion by Michelangelo, and although Vasari* and Condivi* claim to be recipients of his ideas, they were not recorded. Panofsky was the first scholar to suggest that Michelangelo substituted the term *idea* for *concetto* to describe the inner notion of the artist, this was used in opposition to the word *immagine* which referred to the reproduction of an already existing object. The specificity with which these words are used is evident in his sonnets*.

The absence of the term could be explained by Michelangelo's acceptance that it was unattainable, thus adhering to the Neoplatonic* tradition, but given both Vasari and Condivi's accounts of Michelangelo wilfully destroying or abandoning works due to non-realization of the Idea—they use this specific word—this seems improbable (see also *Non finito*). Vasari describes those *concetti*, supposedly unattainable by Michelangelo, not as Platonic ideas however, but as *alti concetti* which necessitated a disproportionate level of skill. The demands of the eye and the spirit or mind were thus engaged in constant conflict. (AB)

63

■ LAST JUDGMENT

T he *Last Judgment* was planned by Pope Clement VII as early as July 1533—perhaps in expiation following the Sack of Rome, which was widely interpreted as a divine punishment for the decadence of the papacy, and of the See of Rome in particular. The project was confirmed by him in February 1534, and again by Paul III; the fresco, on the altar wall of the Sistine Chapel, was unveiled to the public on October 31, 1541. Work on the painting lasted for six years, including one year spent preparing the wall. (Michelangelo retained nothing of the earlier paintings by Pietro Perugino; two lunettes, painted by Michelangelo himself in 1512, were also destroyed).

The fresco sets out to represent the power and glory of Heaven at the end of time; a subject of such magnitude would, Vasari* felt, demonstrate the very heights of greatness attainable through art. Loftier aspirations apart, the painting also achieved perfection in what was then seen as one of the principal skills of art—namely the representation of the human body.

The work was conceived at a particularly troubled period, both in the history of the Roman church, and in Michelangelo's own spiritual life: he was already deeply preoccupied with the salvation of his soul—a notion that obsessed him to the end of his days. Traditionally, representations of the Last Judgment included an ordered exposition of ecclesiastical and secular hierarchies, and an indication of the joys of heaven, as well as the punishments awaiting the damned. Michelangelo, on the other hand, presents a single cataclysmic event of tumultuous power, centered on the colossal figure of Christ the Judge, presiding like an "omnipotent Jupiter." Prey to forces beyond their power, the figures seem to stir in slow motion, adopting every conceivable pose. There is no attempt to contain the scene within a landscape or other setting—the figures float free on the wall's immense surface, on an empty ground painted the deep blue of infinity. Rational perspective is replaced by the organizing principle of the void, one aspect of Michelangelo's concept of *despejo* or "reduction," which he never ceased to "hammer home" to Francisco da Holanda*. The assembly and dispersal of the figures is seemingly governed by a kind of vacuum, between infinity and the abyss. The fresco's "unique, recurring motif . . . the naked body" (André Chastel) caused a scandal in the climate of the Counter-Reformation (see Evangelism and Censorship), but Michelangelo stood his ground. He painted the work, says Holanda, holding fast "to his initial Idea, and his own nature as a great master—not some feeble, cowardly painter who prefers to please those who understand nothing, rather than honor the immortal character [of his subject]." (HS)

Michelangelo, *The Last Judgment*, 1536–41. Fresco, Sistine Chapel, Vatican.

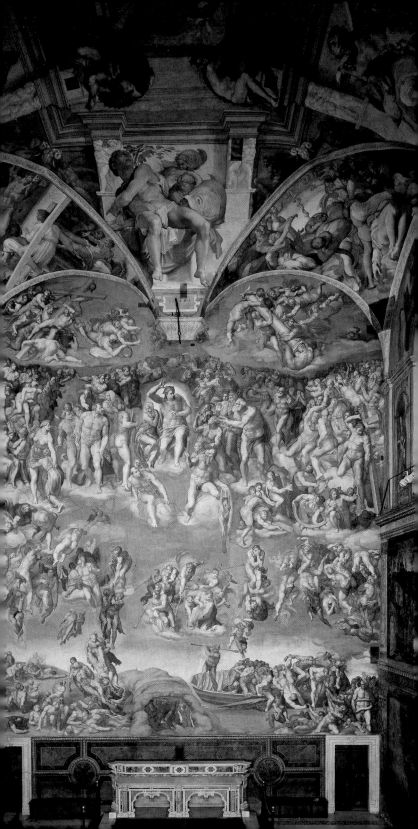

■ Laurentian Library

Plans for a library at San Lorenzo were finalized at the end of 1523: Giulio de' Medici (then pope, under the name of Clement VII) commissioned Michelangelo to create a building above the basilica's monastic accommodation, to house the Medici's extensive collection of volumes, manuscripts and codices. Taking account of the existing medieval buildings, Michelangelo designed a structure supported at intervals by external buttresses. Inside, plain pilasters framing the windows correspond to the position of the buttresses outside, and the beams of the ceiling within. Within this scheme, the desks take their place, logically, beneath the windows. Each window is surmounted by a quadrilateral motif of opposing balusters. The vestibule, or *ricetto,* is in complete contrast to the sober, studious calm of the reading-room. Here, Michelangelo succeeds in taking account of both the external constraints and the wishes of his patron. The *ricetto*'s great height and small floor-plan give rise to a wholly original, expressive ornamental vocabulary: the walls are articulated by recessed, paired columns and tabernacle niches with triangular or broken pediments, surmounted by delicate, garlanded quadrilateral motifs similar to those in the reading room. The monumental triple staircase designed by Michelangelo and executed by Ammanati (1558–59), invades the confined space of the *ricetto*, forcing the visitor's eye upward to the soaring recessed columns and pilasters. With the Laurentian Library, Michelangelo demonstrated the full extent of his architectural genius, and confirmed his reputation as the equal of the ancients. His unorthodox innovations (original designs for the capitals and bases of columns, consoles jutting out beyond the columns they are supposed to support, fluted and cabled pilasters with glyphs beneath), provide an ornamental repertory which was drawn upon by generations of future architects. (FL/YP)

■ Leda

During the siege of Florence* (1529–30), Michelangelo executed a large painting of *Leda and the Swan*, at the request of Duke Alfonso d'Este, whom he had met during his trip to study the celebrated fortifications in Ferrara. The duke had expressed a desire to own a work by Michelangelo many years before, but he was not about to see his wish granted now. According to Condivi*, the indelicacy of the duke's envoy, who described the proposed painting as a "bagatelle, " caused Michelangelo to offer it, together with its cartoon*, to his pupil Antonio Mini, who

Michelangelo,
Vestibule and
stairs,
Laurentian
Library,
San Lorenzo,
Florence.

"He has surpassed and vanquished the ancients, for the facility with which he achieved difficult effects was so great that they seem to have been created without effort."

Vasari, *Lives of the Artists*, trans. George Bull. Harmondsworth: Penguin Classics, © Bull, 1965.

Facing page:
Michelangelo,
*Study for the
Head of Leda*,
1529–30, red
chalk,
14 x 10⅔ in.
(35.5 x 26.9 cm).
Casa Buonarroti,
Florence.

Etienne Delaune
(after
Michelangelo),
*Leda and
the Swan*,
c. 1545.
Engraving,
3⅓ x 5⅓ in.
(8.5 x 13.2 cm).
Edmond de
Rothschild
Collection, Musée
du Louvre, Paris.

took both works to France in 1532. The painting was offered to François I, and taken to Fontainebleau in 1536. There is no further record of it until 1691, when it is mentioned as having been destroyed: "burned by the Queen Mother," Anne of Austria, who found its subject too lascivious. The fate of Michelangelo's *Leda* is an uncertain one, however; was the original burned, or a copy? Vasari states that the cartoon was brought back to Florence by the sculptor, goldsmith, and autobiographer Benvenuto Cellini, but it, too, is now lost. Before it was acquired by the French King François I, Mini is known to have made copies of the painting in Lyon, on his way to Paris. Other copies—drawings and paintings—were also made. The most important of those known today is the very large-scale drawing attributed to Rosso (Royal Academy of Arts, London), executed in Fontainebleau around 1533–38, apparently after the cartoon rather than the painting. Unlike the engravings made after the painting in the

middle of the sixteenth century, the drawing does not show the "bringing forth of the egg from which Castor and Pollux were born," as described by Condivi. Interestingly, the engravings seem to confirm Michelangelo's original Leda as an ideal of physically powerful female beauty (see, too, the figure of *Night* in the New Sacristy* at San Lorenzo). From the relatively few studies of the genesis of the *Leda*, it emerges that Michelangelo may have taken one of his studio's *garzoni* as his model. Perhaps, it is suggested, Mini himself. (HS)

■ Letters

Michelangelo's life is exceptionally well documented, thanks to the accounts of contemporaries, and to his own writings—namely his poetry* and his abundant, complementary, correspondence.

A five-volume edition of 1,400 letters to and from Michelangelo was published posthumously from 1965–83 by Giovanni Poggi, director of galleries for the city of Florence. The first letter in the collection is dated

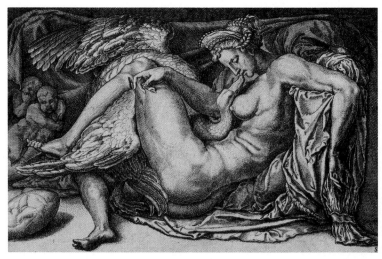

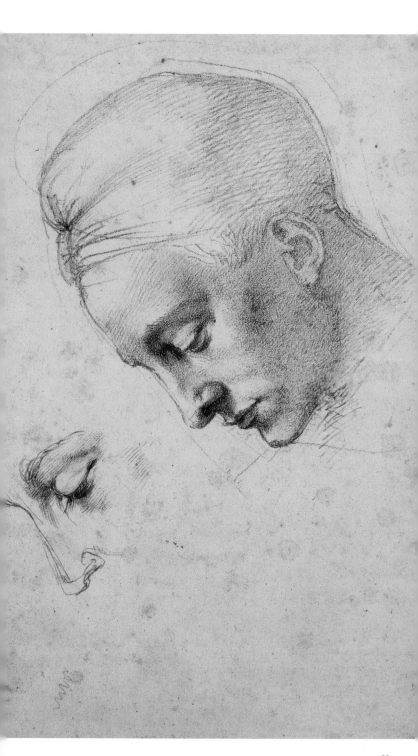

July 2, 1496, the last February 14, 1564 (Michelangelo died four days later); in descending order of quantity, the letters document Michelangelo's relations with his family, his small circle of intimate friends, his patrons and work associates, his benefactors, etc. Absent from Florence, Michelangelo nonetheless emerges as the active administrator of his family's affairs, providing money and advice, chiefly to his nephew Lionardo*, but also to his father and brothers. In Lionardo's case, he seems to have received scant gratitude: "For 40 years, I have supported you", he wrote bitterly on February 6, 1546, "but I have never had anything in return, not even a kind word."

The letters are unsparing in their revelation of Michelangelo the man—his isolation and sufferings; his resentment not only of his jealous rivals and critics, including Raphael and Bramante (see Pope Julius II), but also of those closest to him; his soaring aspirations, crushing doubts and devastating self-criticism, his tormented soul, his spells of exhaustion. In 1542, Michelangelo wrote to his friend Luigi del Riccio: "Painting and sculpture, work and probity have ruined me, and things are only getting worse. In my early years, I would have done better to devote myself to making matches; I would not have suffered my present torments."

In a letter to Vasari* dated February 23, 1556, Michelangelo confided his great sorrow at the death of his faithful servant Urbino: "I owe God many thanks, for while Urbino was alive he showed me how to live, and in his death he taught me how to die, not with grief but with desire ... the better part of me has gone with him. All I have left, indeed, is my infinite distress." To the modern reader, Michelangelo's letters can sometimes read like a dark monologue delivered by a man haunted by thoughts of death, and turning towards his God. They are simple, direct, and plain-speaking—with the exception of those addressed to Tommaso de' Cavalieri* and Vittoria Colonna* (the latter were revised by Gianotti*). Richly metaphorical, Michelangelo's letters to the two great loves of his life are notable, too, for the beauty of their handwriting. (HS)

Michelangelo's handwriting, from a petitioning letter to Leon X regarding Dante's tomb, 1518. State Archives, Florence.

■ LIONARDO
"The beloved parasite"

Michelangelo's nephew Lionardo Buonarroti (1522–99) made his first significant entry into the artist's life at the age of eighteen, having been brought up in Settignano by his three other uncles, after the death of his father Buonarroto Buonarroti Simoni (1477–1528). Their relationship was essentially epistolary—with no great affection or gratitude on Lionardo's part, at least. In the 23 years during which they exchanged letters, from July 1540 to December 1563, Lionardo saw his uncle only five times, and failed to reply when Michelangelo expressed a wish to see him again shortly before his death.

For his part, Michelangelo loved his nephew like a son, using every means at his disposal to inculcate in him—from a distance—a sense of values and principles. The artist's letters are full of urgent and affectionate advice on how his nephew should conduct his life. He also sent money—and here Lionardo, as the family's sole male heir, proved far from disinterested, not to say greedy. He acquired houses, land, shops, with the aim of becoming a wool merchant, and Michelangelo, while not blind to his nephew's true motivation (the prospect of a tidy inheritance) covered all the expenses. His generosity extended, too, to the bride he had urged Lionardo to marry—Cassandra Ridolfi, from one of Florence's noblest families. Michelangelo was relying on

The Casa Buonarroti, Florence.

his nephew to carry on the noble line of the Buonarotti, and in this at least, Lionardo did not shirk his responsibilities. The same could not be said of his search, at Michelangelo's request, for a respectable townhouse in Florence. Lionardo set about the task half-heartedly and tardily, partly rebuilding some houses on the Via Ghibellina, acquired by Michelangelo between 1508 and 1514. The Casa Buonarroti, Michelangelo's long-dreamed-of small family *palazzo*, was the work of his great-nephew, Michelangelo Buonarroti il Giovane (1568–1647). (HS)

■ Madonna of the Stairs

The *Madonna of the Stairs* is now generally agreed to be Michelangelo's first known work, carved during his time at the garden of San Marco*. A work, then, from his earliest years, and one which (according to Vasari*) he kept in his house in Florence until his nephew Lionardo* offered it to Duke Cosimo I. (The relief was returned to the Casa Buonarroti in 1616).

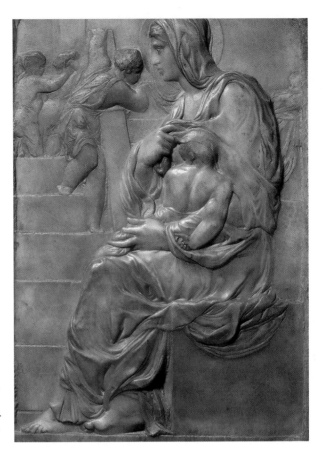

Michelangelo,
*Madonna
of the Stairs*,
c. 1490. Marble,
22½ x 16 in.
(57.1 x 40.5 cm).
Casa Buonarroti,
Florence.

Vasari also writes that, "when he was still a young man, [Michelangelo carved the relief] after the style of Donatello, and he acquitted himself so well that it seems to be by Donatello himself, save that it possesses more grace and design." In fact, the *Madonna of the Stairs* is not a slavish copy of Donatello's *rilievi schiacciati* (or "flattened reliefs") on the same theme, which Vasari clearly had in mind. The *schiacciato* technique is used here in a quite different spirit, as a way of emphasizing the massive form of the Virgin in the foreground, and her tragic solitude. This is a sentiment entirely absent from Donatello's treatment, which focuses on the tender affection between Mother and Child. In Michelangelo's version, the Virgin stares gravely ahead, seemingly indifferent to the Child at her breast. Michelangelo apparently borrowed his motif from Greek funerary steles, which often feature seated female figures in profile. He transforms "the oblivion of their departed souls ... into a Mother's prophetic awareness of the fate of her Child" (Charles de Tolnay). The message of sacrifice seems implicit in the Child's physical abandon, as if slumbering in death, and in the sheet held up by two *putti* behind the

Virgin, which may be seen as an allusion to Christ's shroud. The stairs from which the relief takes it name are a reference to the Marian epithet *Scala Coeli*, the "stairway to Heaven," the means by which heaven and earth are joined. Recent studies suggest that the smooth surface of the relief, and the heavy handed treatment (not to say complete absence of modeling) of the Virgin's hands and feet, are the result of clumsy over-polishing after Michelangelo's death. (HS)

The fresh green years cannot imagine how much
one's tastes and loves, desires and thoughts all change,
my dear Lord, as the final steps approach.
The soul gains more, the more it loses the world,
and art and death do not go well together;
in which, then, should I place my further hope?

Michelangelo, fragment (possibly of a sonnet), no. 283, trans. Saslow.

■ Manchester Madonna

The so-called *Manchester Madonna* may be identified with the "painting by Buonnaroti, unfinished, representing the Virgin and Child with St. John the Baptist surrounded by four angels," described in a work on the Villa Borghese published in Rome, in 1700. It is listed again in the inventories of the Borghese collections in 1765, but was subsequently lost until it reappeared at auction in London, in 1833. It takes its popular title from its first public exhibition following the sale, in Manchester in 1857. It was bought by the National Gallery, London, in 1870. However, the painting's attribution to Michelangelo was contested in favor of Domenico Ghirlandaio (his first master) even before its exhibition in Manchester, and the controversy has raged ever since. For some, the painting is clearly an early work by Michelangelo, while others see it as the work of a pupil, himself the object of several identification attempts prior to Federico Zeri's assertion in 1953, that the picture's originality and quality of execution qualified it as the

most important of a group of works by the so-called "Master of the *Manchester Madonna*"—a painter active in Michelangelo's studio in Rome in the late fifteenth century or early sixteenth century. Recently, however, the attribution to Michelangelo seems to have become more widely accepted, and the work is generally held to be the first known example of his activity as a professional painter. But when and for whom was it painted? Michael Hirst has recently suggested a date of 1497, in reference to a document of June 27 of that year, according to which Michelangelo, then in Rome, withdrew a small sum of money from his bank account for the purchase of a wooden panel *per dipignerlo*, "to be painted upon." The painting's unfinished state could then be explained by the major commission which the artist received just a few months later, for the *St. Peter's Pietà**. Other historians date the painting to the artist's stay in Bologna*, or even earlier (c. 1492–94), perhaps for a Florentine patron, in light of the intercessory role of St. John the Baptist, the city's patron saint. (HS)

Following page: Michelangelo, *The Virgin and Child with St. John the Baptist and Angels*, known as the *Manchester Madonna*, c.1495–97. Tempera on panel, 3 ft. 5 in. x 30⅓ in. (104 x 77 cm). National Gallery, London.

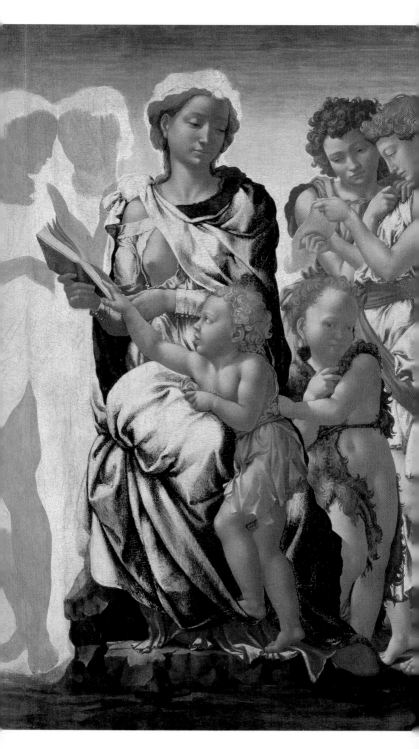

▪ Medici (The)

Throughout Michelangelo's life the Medici family dominated political and cultural life in Florence. They were expelled from Florence twice (1494–1512 and 1527–30) but on both occasions they managed to regain both their power and influence. Their wealth stemmed from banking activities, supplying credit to some of the major Italian courts, and it enabled the family to become among the most celebrated patrons and collectors of their time.

Lorenzo the Magnificent (1449–92) was the first of Michelangelo's Medici patrons, but the artist was by no means loyal to the Medici cause. From 1501 he embarked on a series of commissions for the Republic: notably the *David**, the *Apostles,* and the *Battle of Cascina** (it should be noted, however, that works were executed concurrently for Lorenzo di Pierfrancesco from the Cadet branch of the family). When Florence was re-proclaimed a Republic in 1527, Michelangelo's loyalties again became apparent when work on his Medici commissions (the New Sacristy* and Laurentian Library*) came to an abrupt halt, and work on a marble *Hercules* or *Samson* for the Republic began. When Medici rule was restored in 1530, he was prompted to seek refuge, no doubt due to his official role as one of the "Nine" of the Republican Militia in 1529. He returned to Florence only after having been pardoned by the Medici Pope Clement VII. Clement lured Michelangelo to Rome in 1534, where he began painting of the *Last Judgment**. The pontiff seemed unconcerned that this commission meant the abandonment of the

Medici tombs*, no doubt driven by a desire to put his own mark on the Sistine Chapel.

After Clement VII's death that same year, Michelangelo evaded Medici commissions. The dynamic between the two parties shifted during the last fourteen years of his life when Duke Cosimo I made various attempts (aided by Vasari* and Benvenuto Cellini) to entice the artist back to Florence. This would have been something of a propaganda coup, to follow the decisive defeat of the Republican army in 1554. Michelangelo, after some deliberation, remained in Rome, although in 1558 he was coerced into sending a model for the Laurentian Library staircase. In 1560, a form of 'reconciliation' was reached when Duke Cosimo and his son received Michelangelo during their state visit. After Michelangelo's death, Cosimo arranged to have his body returned to Florence for his quasi-state funeral* and burial in the city's "pantheon," Santa Croce. (AB)

Page 77:
Michelangelo,
Tomb of Lorenzo de' Medici,
c.1520–34.
Marble.
San Lorenzo,
New Sacristy,
Florence.

Sebastiano del Piombo, *Portrait of Clement VII,* c. 1526. Oil on canvas, 4 ft. 9 in. x 3 ft. 3 in. (1.45 x 1 m). Museo di Capodimonte, Naples.

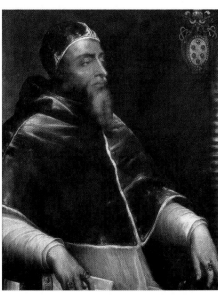

■ MEDICI TOMBS

Situated in the New Sacristy* at San Lorenzo, the tombs of Giuliano de' Medici (Duke of Nemours) and Lorenzo (Duke of Urbino) were commissioned by the Medici Pope, Clement VII, and are situated on the lateral walls of the chamber. A double monument on the entrance wall, for their forebears Giuliano and Lorenzo, the so-called *Magnifici*, was also planned, but only a *Virgin and Child* and two workshop pieces of the Florentine saints Cosmas and Damian were produced. Elements carved by Michelangelo can be dated to 1524–34.

The Medici figures are presented in military uniform as fanciful Roman *capitani*, seated in recessed niches flanked by paired Corinthian pilasters (a motif with triumphal connotations). Neither of the dukes were celebrated military leaders, however, and the armor instead serves to present them as "captains" of the Medici dynasty. Nor are the images exact portraits, but instead represent an ideal. The effigies, and the sarcophagi, accompanying figures, and decorative sculpture below have been carved with great sensitivity to the spatial complexities of the chapel, Michelangelo being ever-mindful that they would be viewed from a variety of vantage points. Giuliano's elongated neck and projected chin seem awkward when viewed from a high vantage point, but from below this device lends a certain elegance to the latent power of his physique. His watchful demeanour contrasts with the more contemplative pose of his counterpart, Lorenzo.

Figures of *Dawn* and *Dusk* recline upon Lorenzo's sarcophagus; their counterparts *Day* and *Night* rest on that of Giuliano. The two male figures, *Day* and *Dusk*, are both unfinished. In common with much of the rest of his oeuvre, Michelangelo has given them no identifying attributes, unlike the finished female figures, representing *Night* and *Dawn*. *Dawn* wears a girdle and casts aside her veil, and *Night* is adorned with a diadem featuring a crescent moon and a star. She is also accompanied by an owl, and rests her foot upon a sheaf of poppies, a reference to somnolence. The meaning of the grotesque mask beneath her left elbow is less certain, but might represent the realm of dreams and the absence of reason. The figures might also be interpreted as embodiments of motherhood—note the wrinkled folds of *Night*'s stomach—and inexperience, given *Dusk*'s more youthful bodily type.

The differing degrees of finish on the statues have been variously interpreted by modern commentators, and can, in some instances, seem to deliberately enhance the figures' expressive meaning. Claw chisel marks are still visible on the surface of Lorenzo's effigy, in contrast to the crisp polish given to the figure of Giuliano, and the unfinished effect certainly enhances Lorenzo's mood of introspection. Similarly, the rough surface and deeply-cut profile of the unfinished head of *Day* can only be read "pictorially," even impressionistically, in the context of the prevailing daylight within the chapel, while the finished figure of *Night* is resolutely sculptural and could indeed be "read" by touch, in complete darkness. It seems highly unlikely that any

of this was intentional on Michelangelo's part, however. A drawing for the figure of *Day* in the Ashmolean Museum, Oxford, shows the head in a similarly unfinished state in comparison to the body, but this may be due to his overriding concern for bodily form. Equally, the potentially deliberate character of Lorenzo's partial *non finito* is contradicted by the high degree of polish visible on the statue's left arm.

Had these sculptural complexes been completed, the theme or symbolic content of the chapel as a whole might be more clearly read. Condivi* states that Michelangelo had reserved a small block of marble for a mouse, an allegory for "time devouring all." This theme of transience is hinted at in Michelangelo's own words. Inscribed on a drawing (Casa Buonarroti, Florence) is a dialogue between *Day* and *Night* which, in simplified terms, suggests that the ephemeral is compensated by the perpetuation of fame, that is, through the permanence of sculptural form. Eternal life is also promised in Christian terms, aided by the intercession of the Virgin, to whose sculptural form Giuliano and Lorenzo direct their gaze. (AB)

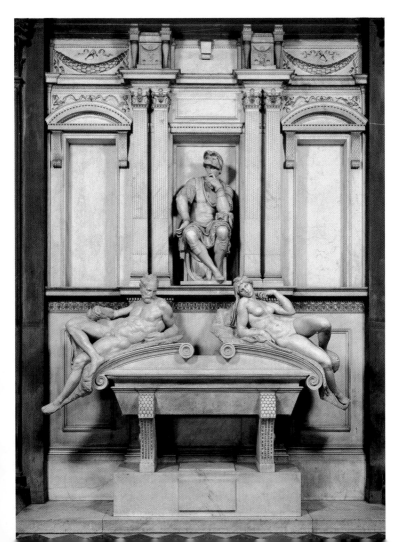

Facing page:
Monument to Michelangelo, 1564–78. Santa Croce, Florence. The bust of Michelangelo and the figure of *Painting* are by Giambattista Lorenzi, the figure of *Sculpture* by Valerio Cioli (after 1573), *Architecture* by Giovanni Bandini (1568); the paintings are by Giovanni Battista Naldini.

Michelangelo, *River God*, c. 1524–27. Clay and wood. 25⅔ x 55 x 27⅔ in. (65 x 140 x 70 cm). Florence, Casa Buanorotti.

Modelli

The making of models for sculptural works was of prime importance in the workshops of Michelangelo's contemporaries, for both aesthetic and technical reasons. Michelangelo, who generally made his own figural models, used them in conjunction with drawings as guides for the stonecutters (*scarpellini*) in Carrara, and also as guides for his assistants. These *modelli* were also much in demand by other less capable artists, who sought to learn from Michelangelo's modeling technique.

Models were executed in clay, wax, and wood. The fragile nature of these media means that very few survive: all nine models attributable to Michelangelo's own hand are in the Casa Buonarroti, Florence (this figure is debatable given the complex issues of authorship due to their disparities of finish and detail).

Michelangelo was a prolific and renowned "modeller" (numerous portraits depict him surrounded by *modelli*), a skill probably acquired in his formative years in the sculpture garden at San Marco*; the making of models was an important part of the learning process, akin to the value of drawing for painters. He may also have been influenced by the Bolognese predilection for terracotta models (molded in clay and then fired in a kiln) during his stay, in 1494–95 (see Bologna). Exceptionally, full-scale models were made for the figures in the New Sacristy*, of which the only survivor is a River God (clay and other materials), destined for the tomb of Lorenzo de' Medici, to be situated under the left-hand side of the sarcophagus. As a rule, such figures were contrary to Michelangelo's practice. In the case of the New Sacristy, they

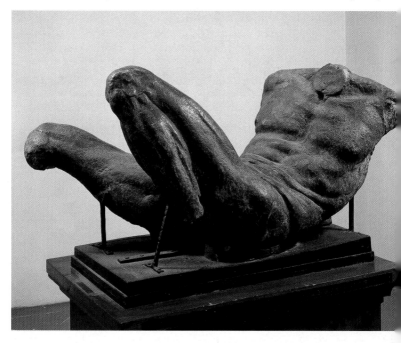

perhaps served to convince the Medici that this seemingly unfeasible plan was in fact realizable; ultimately, however, increasing pressures of time, post-1533, meant that Michelangelo's *modelli* served as guides for assistants who were brought in to expedite the work.

Only one *modello* of a group of figures survives from Michelangelo's corpus—the so-called Hercules and Cacus or Samson Slaying a Philistine (terracotta). Both the subject-matter and the project for which the work was destined are in dispute, but it is possible that it was conceived as a pendant to the David*, c. 1528. (AB)

■ MONUMENT TO MICHELANGELO
The archetype of the artist's tomb

Michelangelo was buried in the Florentine "pantheon" of Santa Croce. His tomb, paid for by the artist's heirs and the Medici family, was executed by the Accademia del Disegno*, seizing an excellent chance to publicize itself. Having discarded the idea of a public competition, the Accademia designated three young sculptors for the task, working from a model designed by Vasari*.

The project ran into difficulties, however. First planned in 1564, it was not finished until 1578. Several versions were proposed before the final design was approved by Cosimo I; before and after this, the iconographic program, too, was endlessly discussed and revised. Matters were not helped by Lionardo* Buonarroti who— balking at the cost, irritated by the project's slow progress, and dissatisfied with the sculptors—intervened late in the proceedings to limit the sculptural program as initially planned in favor of painted decorations, at his own expense. The rejected elements included a low-relief Pietà (replaced by a painted version of the same subject), which had been intended as a reference to the group carved by Michelangelo for his tomb, but which he subsequently broke up (now re-constituted and housed in the Duomo, Florence); and emblems and devices alluding to the financial support provided by the Medici and the role of the Accademia del Disegno. Despite this, the Accademia still viewed the project as very much its own, celebrating Michelangelo as the embodiment of the school's treasured concept of the unity of the so-called "design arts"—painting, sculpture, and architecture. As Zygmont Wazbinski has shown, the sculptors employed on the scheme used it to express their own intellectual aspirations. The allegorical figure of *Sculpture*, for example, strikes a pose similar to that of the *Melancholy*, highlighting intense reflection on the part of the sculptor, rather than his physical exertion, as was more traditionally the case.

Michelangelo's funeral was without doubt the high point of the artist's personal cult. Michelangelo's tomb, the funeral's centerpiece—including a portrait bust, personifications of the arts, and an epigraph—became the archetype, in both form and content, of its kind. (HS)

Neoplatonism

It has been tempting for art historians such as Charles de Tolnay to impose the principles of Neoplatonic theory on Michelangelo's artistic ideology. The figurehead of this philosophical trend was Marsilio Ficino (1433–99) who was sponsored by both Cosimo and Lorenzo de' Medici. The "Platonic Academy," led by Ficino, was an informal club of intellectuals, and not a formal institution, which fostered a new reading of Plato, heavily reliant on the mystical approach of the third-century Roman philospher Plotinus. Ironically, Ficino contributed to the rise in status of the painter—the profession came to be seen as symbolic of man's creative power and his ability to achieve perfection by transcending the natural world—while at the same time maintaining a particular distrust of sculpture and, in the spirit of Plato's *Republic*, considering works of art in general to be illusory and third-rate imitations of the "Ideal."

It is highly improbable that Michelangelo would have read Ficino's Latin translations of Plato's works, but he may have been receptive to a dilute version of some of the technicalities. Loose links can be established with some of his later verse*, in particular notions of beauty, love, and divine frenzy. However it is probably unwise to interpret unfinished figures such as the *St. Matthew*, now in the Galleria dell'Accademia, Florence, as having been left deliberately "imprisoned" in their blocks of stone in order to a express a visual metaphor for the captivity of the soul in

the body (see *Non finito*). Certain passages in Condivi's* *Life* might be interpreted as evidence of Michelangelo's incorporation of private, Neoplatonic symbolism in his work, however Condivi's remarks are generally linked to commissions whose subject matter has been provided by the patron, and subsequently dramatically interpreted by Michelangelo, rather than any personal ideology. Michelangelo's resulting work is, then, a dramatic interpretation of a pre-determined subject, rather than a spontaneously conceived artistic expression of any personal ideology. (AB)

■ New Sacristy at San Lorenzo

As early as 1519, Cardinal Giulio de' Medici planned to build a chapel and library at the "Medici church" of San Lorenzo. The chapel (in fact a mausoleum housing four Medici tombs) was planned as the pendant to the sacristy built by Brunelleschi at the far end of the opposite arm of the transept, hence the buildings' now familiar titles: the Old and New Sacristy. Michelangelo took account of the project's inherent constraints (the dimensions, and the tripartite articulation of the alter wall punctuated by Corinthian pilasters), but employed a totally different decorative scheme. Marble replaced the white plaster of the ground floor, and the fluted pilasters in the latter's corners gave way to piers; the side bays destined to house the Medici dukes' tombs were decorated with, on one side, an aedicula with a console and broken pediment, and, on the other, with a niche to hold their statue. The niches themselves are enclosed within double pilasters with innovative composite capitals. Michelangelo added an intermediary level with windows framed by fluted pilasters placed above the supports of the lower stories,

Michelangelo, *Infant Bacchanalia*, 1533. Red chalk, 11 x 15⅔ in. (27.4 x 38.8 cm). Royal Library, Windsor Castle.

Pages 82–83: Michelangelo, New Sacristy, San Lorenzo, Florence.

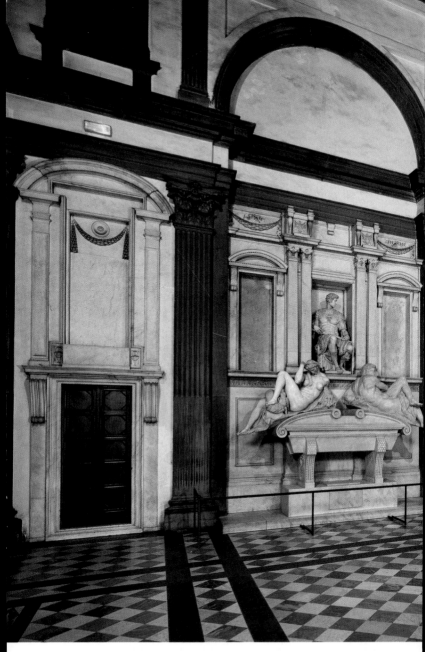

creating a vertical dynamic unseen in the Old Sacristy. The third story, with upwardly tapering central windows, received the pendentives needed to support a coffered dome. The lantern is the first example of the use of columns with a stepped entablature supporting buttresses in the form of volutes, themselves supporting the roof. In contrast to the Brunelleschian simplicity of the Old Sacristy, where form and function are harmoniously combined, Michelangelo uses architectural elements with sophistication to provide a framework for sculpture (tombs, sarcophagi, effigies).

Above the doors, tabernacles articulating the interpenetration of the various elements (entablatures "over-running" the bases of pilasters and pediments alike, and the latter projecting outwards for the most part) show the same formal inventiveness as the *ricetto* of the basilica's Laurentian Library*. (FL/YP)

"Dear to me is sleep, and dearer to be of stone while wrongdoing and shame prevail; not to see, not to hear, is a great blessing: so do not awaken me; speak softly."

Michelangelo's response to an epigram by Carlo Strozzi, quoted in Vasari, *Lives*, trans. George Bull. Harmondsworth: Penguin Classics, © Bull, 1965.

Non finito

The unpolished appearance of some of Michelangelo's sculptural works is often mistaken for a conscious technique or ideological principle, perhaps influenced by our Post-Impressionist approach to art. Michelangelo's concern for appropriate finish is demonstrated in a number of letters of 1521–22, which refer to the statue of the *Risen Christ* (Santa Maria sopra Minerva, Rome): unhappy with the results produced by the two sculptors he sent to complete the work, he subsequently undertook the finishing himself. Similarly, Condivi* relates how Michelangelo had been critical of the rough surfaces in Donatello's work. Due to a lack of documentation we are at a loss to explain the absence of finish in some works, such as the *Pitti* and *Taddei Tondi*. The constant demands of patrons, however, can explain the unfinished status of works such as the *St. Matthew* (Accademia, Florence). Commissioned in 1503 as one of a series of statues of the twelve apostles for the Duomo in Florence, the figure was due to be delivered by the end of 1504. It seems probable, however, that the figure was not begun until 1505 due to the pressure of work on the *Battle of Cascina**; the project eventually came to a halt when Pope Julius II called Michelangelo to Rome in 1508. Michelangelo's renown, however, ensured that many of these unfinished works were preserved for posterity.

Vasari cited Michelangelo's frustrated creative genius as an explanation for the lack of finish of many of his works. This is, to some extent, an example of his myth-making tendency, but his theory is applicable to the *Florentine Pietà* (Museo del Opera del Duomo, Florence). Begun in the 1540s, probably for his own tomb, the sculpture was deliberately damaged by Michelangelo sometime before the end of 1555. It seems probable that he was frustrated not only by the quality of the stone—the first *Risen Christ* was abandoned for the same reason—but also by his own unceasing quest for perfection. (AB)

Ornamentation

Inventive ornamentation is one of the chief characteristics of "Michelangelesque" architecture. There can be no doubt that the artist knew the antique vocabulary of Vitruvius, as witnessed by (probably) his own drawings, copied from one of the period's most celebrated antique codices, the Codex Coner. Unlike his contemporaries, however, he applies the classical rules and norms—which theorists of the time sought so painstakingly to update—with extraordinary freedom. He was more than capable of working within the constraints of the Corinthian order (as at St. Peter's* or the Capitol*), or of retaining original, unmodified antique columns in his work, as at Santa Maria degli Angeli. But neither does he hesitate to "pervert" the forms of the antique canon (as with the "Ionic" capitals on the upper register of the Palazzo dei Conservatori), or to design new moldings (as in the *ricetto* of the Laurentian Library*, the surrounds for the tombs of the New Sacristy*, the Porta Pia*). He is capable, as in the third story of the courtyard of the Farnese Palace*, of combining a textbook Corinthian capital with a totally original

Michelangelo, *Saint Matthew*, 1505–06. Marble, h. 8 ft. 11 in. (2.71 m). Galleria dell' Accademia, Florence.

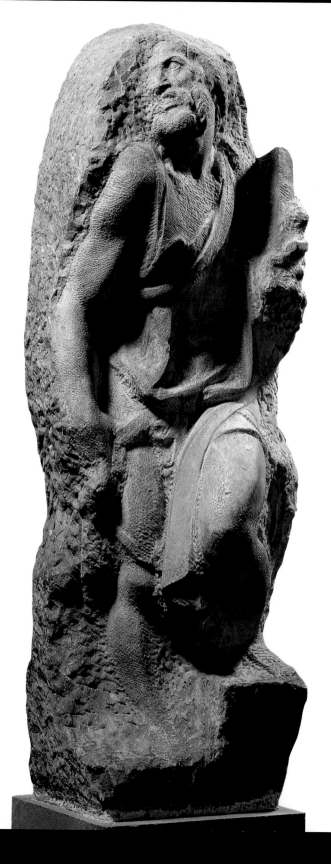

entablature, drawing on Doric elements, to create a *mescolanza*, a "composite," which drew the enthusiastic admiration of Vasari, but also the vehement condemnation of the rigorous "Vitruvians."

This freedom applies to every element of the ornamental repertory. Abstract classical forms, such as ovoids, are deliberately metamorphosed into grotesque masks (New Sacristy); window frames seem to have no defining logic (the courtyard of the Farnese Palace). Each individual element of the repertory is re-deployed in new contexts completely unrelated to their original substance (Porta Pia).

Late sixteenth- and early seventeenth-century architects drew abundantly on this rich repertory of ideas, just as painters copied and learned from the cartoon of the *Battle of Cascina** and the Sistine Chapel vault* frescoes. By slavishly copying Michelangelesque forms, however, they created a new kind of academism, ultimately betraying the very principle of freedom that had governed their creation. (FL/YP)

Michelangelo, *Tomb of Lorenzo de' Medici*, detail from the base of the sarcophagus. San Lorenzo, Florence, New Sacristy.

■ Painting

We do not know for certain with whom Michelangelo first trained as a sculptor, although Vasari notes that the elderly bronze sculptor Bertoldo was employed as curator and tutor at the garden of San Marco* when the young Michelangelo studied there (see Michelangelo: Knowledge, difference, paradox). On the other hand, his early training as a painter with the Ghirlandaio brothers, Domenico and Davide, is well documented despite attempts at the end of his life, through Condivi*, to alter the record. The contract assigning the young Michelangelo to the Ghirlandaios' studio for a three year period from April 1, 1488, was known to Vasari. Another recently-discovered document records his presence in the studio as a paid junior assistant, at just 12 years of age, in June 1487. Inevitably, attempts have been made (fruitlessly) to discover Michelangelo's hand in the frescoes of the Tornabuoni Chapel at Santa Maria Novella in Florence, upon which Domenico and the studio were engaged at the time.

Beyond the documentary evidence, the Ghirlandaios' influence on Michelangelo's painting has become increasingly clear with the restoration of his own panels and frescoes. The cleaning of the Sistine Chapel* vault for example, revealed Michelangelo as a painter steeped in the Florentine tradition. The frescoes show a degree of technical perfection which is clearly attributable to the presence on the scaffolding of assistants brought to Rome, for the most part, from the Ghirlandaio studio in Florence. Further evidence is provided by two panel paintings at the National Gallery, London, which are—albeit controversially—attributable to Michelangelo: the *Manchester Madonna**, dated c. 1492–97, and the *Entombment*, which has been identified as an unfinished altarpiece for the church of Sant'Agostino in Rome, painted in the winter of 1500–01. Despite being painted in different media (tempera and oils,

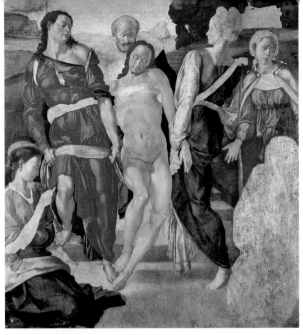

Michelangelo, *Entombment*, 1500–01. Oil on panel, 5 ft. 3 in. x 4 ft. 11 in. (1.62 x 1.50 m). National Gallery, London.

respectively), both pictures share the same particularity of execution: certain figures or parts of figures are almost finished, while others have been left untouched, showing only the under-drawing. This method recalls the *giornate* of fresco painting (working in sections, each representing a day's activity), and has been linked to the methodical sharing-out of work observed at the Ghirlandaio studio. Another particularity (besides the use of tempera—a technique also employed by Michelangelo for the *Leda**, according to Vasari) is the use of a *terra verde* ground for the flesh colors. This has clearly been used for the figure of the *Manchester Madonna*, and is visible in the limbs and faces of the two unfinished angels on the left of the panel. It should be noted that neither of the London panels are mentioned by Vasari* or Condivi*, unlike the *Doni Tondo*, which Vasari describes as the finest and most finished of Michelangelo's few panel paintings, or the *Leda* (now lost). Perhaps Michelangelo was unsatisfied with the

works, and preferred not to keep them. It has often been noted that he painted less and less as his career progressed. Painting was not his trade, he said, and it was reported that he was reluctant to accept the commissions for the Sistine* and Pauline Chapels*—works that left him physically exhausted, but which he nonetheless saw through to completion. (HS)

■ Pauline Chapel

The *Conversion of St. Paul* and the *Crucifixion of St. Peter*, painted facing each other on the side walls of the Vatican's Pauline Chapel, are Michelangelo's last known paintings. Prior to the completion of the *Last Judgment**, Pope Paul III (Alessandro Farnese) had already decided to entrust Michelangelo with the decoration of his new private chapel. He never saw it completed. Michelangelo accepted the commission reluctantly, writing that, "I can refuse Pope Paul nothing: I will paint discontentedly, and do discontented work". Work began in the fall of 1542 and continued until spring 1550; it was

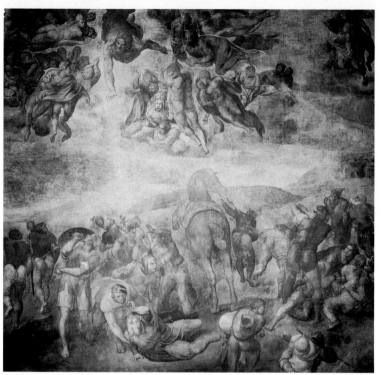

Michelangelo,
*The Conversion
of St. Paul*,
1542–45. Fresco,
20 ft. 6 in. x
21 ft. 8⅓ in.
(6.25 x 6.61 m).
Pauline Chapel,
Vatican.

Facing page:
Michelangelo,
*Standing Virgin
with the Infant
Jesus and St John
the Baptist*; lines
from a poem
c. 1500 (c. 1520
for the poem).
Pen and brown
ink, 12¼ x 8¾ in.
(31 x 22 cm).
Department of
prints and
drawings, Musée
du Louvre, Paris.

interrupted twice by illness on the part of Michelangelo (in 1544 and 1546), and once by fire (1545). The exact chronology is unclear, but the *Conversion of St. Paul* is generally agreed to be the earlier of the two frescoes. It certainly shows the closest similarities to the *Last Judgment*, particularly in the wealth of foreshortening, and the closely packed cohort of nude angels clustering around the figure of Christ. Once again, Michelangelo presents a vision of humanity seized with dread before the omnipotence of the Divine: St. Paul, struck down and blinded by the sudden flash of heavenly light, hears the voice of God, as do his awe-struck companions, fleeing in all directions from the path of a terrified, bolting horse. The *Crucifixion of St. Peter* features the same undulating, denuded landscape, but a total absence of agitation or violence: just a slow, silent procession of soldiers and dumbfounded onlookers,

describing a broad circle around the cross and seemingly extending beyond the picture, into the space of the chapel itself. As in the *Conversion of St. Paul*, Michelangelo uses figures truncated at the picture's edges as a means of implicating the viewer, extending an invitation to enter into the theatre of action, and encounter Christ.

There is an autobiographical element to the austere world of the Pauline Chapel. The *Conversion of St. Paul* has been seen as an account of Michelangelo's own moment of divine revelation. The picture illustrates the spiritual theme of enlightenment through the grace of God, central to religious debate at the time. The need for grace—attainable only through the soul's intimate union with God—and for salvation through faith, were firmly-held beliefs often expressed by Michelangelo towards the end of his life, both in his letters* and his poetry*. (HS)

Poetry

Michelangelo left some 300 finished poems and fragments, sometimes jotted down among sketches on a sheet of studies, or on the back of a letter. The first are datable to 1503, the last to 1560, but his most productive period—with a clear preference for short metrical verses such as madrigals, sonnets, and quatrains—was from 1534 to 1547, when he composed the works dedicated to Tommaso de' Cavalieri* and those inspired by Vittoria Colonna*. The remarkable series of fifty short epitaphs for Cecchino Bracci—the nephew of his exiled Florentine friend Luigi del Riccio, who died at age 15 in January 1546—also dates from this period. Michelangelo worked with Giannoti* and Luigi del Riccio on a collected edition of his poetry, but abandoned the project following del Riccio's death, late in 1546, and that of Vittoria Colonna in February 1547, after which he wrote less and less. A collection of 137 of Michelangelo's poems was finally published in 1623 by his great-nephew Michelangelo Buoanrroti il Giovane (1568–1642), with some modifications: the most passionate of the love poems addressed to men were transposed to the feminine gender.

Michelangelo's poetry was—as his critics gleefully pointed out—erratic, difficult, and even grammatically incorrect. It was certainly bitter, harsh, and direct, and as such, it retains a remarkable appeal for the modern reader. Michelangelo was influenced by Dante—particularly the latter's *Poems for the Lady of Stone*—and Petrarch, whose works helped him to find his own poetic voice. Michelangelo's poetry is both meditative and confessional, with a marked taste for antitheses and word-play. Using imagery drawn from his own experience as a painter and (especially) sculptor, his themes are the transience of life, the power and torment of love, the transcendental value of beauty; transgression and death. A few poems are inspired by topical political issues, such as the compromise and weakness at the heart of the Roman church, or the fall of the Florentine republic. After 1547, however, religious themes predominate. With devastating honesty, Michelangelo expresses his loss of faith in the redemptive and transcendental powers of art. That which had been his lifelong passion now came to seem idolatrous, even blasphemous to him: "so now I recognize how laden with error / was the affectionate fantasy / that made art an idol and sovereign to me /… Neither painting nor sculpture will be able any longer / to calm my soul, now turned toward that divine love / that opened his arms upon the cross to take us in." (HS)

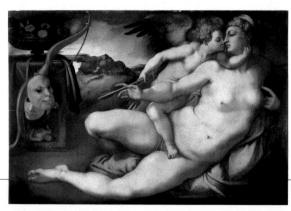

■ PONTORMO
"Drawn by Michelangelo, painted by Pontormo"

Michelangelo's association with Jacopo Carucci (1494–1557), known as "Il Pontormo," was both surprising and fascinating—the more so since both men were noted for their solitary temperament, which bordered on the neurotic in Pontormo's case, as evidenced by the strange journal kept in the last years of his life. The two artists were first called upon to collaborate in the early 1530s, following the siege of Florence*, at a time when Pontormo, Michelangelo's junior by almost twenty years, had already painted his masterpiece, the *Entombment,* for the altar of the Capponi Chapel at Santa Maria Felicità in Florence (c. 1526). Vasari* describes how Michelangelo was commissioned by Alfonso d'Avalos, Marquis del Vasto and commander of the army of Charles V, to produce a cartoon of a *Noli Me Tangere* (the risen Christ implored by Mary Magdalen, now lost). With Michelangelo's blessing and under his close supervision, the work was rendered in paint by Pontormo. The resulting work, now in a private collection, was hailed as "exceptional, as much for Michelangelo's drawing as for Jacopo's color." Following the success of this collaboration, the Florentine banker and merchant Bartolomeo Bettini commissioned a *Venus and Cupid* (now lost). Once again, the cartoon was to be executed by Florence's greatest draftsman, Michelangelo, and the painting produced by the city's greatest colorist, Pontormo. The result was again hailed as "prodigious." But Bettini did not enjoy his picture for long. Vasari tells how Duke Alessandro de' Medici made off with the painting, to Michelangelo's great annoyance. Michelangelo/Pontormo's *Venus and Cupid* was celebrated by contemporary commentators, and much copied. Vasari painted at least three versions himself, from 1541–44. For Pontormo, the painting was the starting-point for a lifelong exploration of the theme—the preoccupation of almost the whole of the rest of his career. (HS)

■ Pope Julius II

Giuliano delle Rovere (1443–1513) was the nephew of Pope Sixtus IV (who reigned from 1471–84), to whom he owed his own rapid rise through the ranks of the Church, becoming pope in 1503, under the name of Julius II. He devoted himself forthwith to the pacifying and reorganization of the Papal States. After joining the Anti-Venetian League of Cambrai (1509), he effected a turnabout that enabled him to present himself as the "liberator of Italy," creating an ultimately successful alliance (1511) with Venice, Naples, Ferdinand II of Spain, and Switzerland, against the old "barbarian" enemy, France. Finding himself on the brink of war, he did not hesitate to join in the fighting; in November 1506, Erasmus was shocked by the spectacle of

Pope Julius II's triumphal entry into Bologna, in full armor.

An inscription put up on the Via Banco San Spirito in Rome, in 1512, describes Julius' other main sphere of activity: "Julius II, having extended the dominions of the Holy Roman Empire and liberated Italy, went on to embellish Rome, which then resembled a conquered rather than an harmoniously ordered city, by tracing and opening-up new thoroughfares according to a plan befitting the grandeur of his Empire." Like his uncle, who earned the title *restaurator Urbis*, Julius II labored to restore the Eternal City to its former splendor. Bramante was his chosen architect, and it was to him that Julius entrusted the reconstruction of St. Peter's* (the church of the prince of the apostles should "be judged finer than any other in the city, or the world," he declared in 1509), as well as the remodeling of the Vatican's famous Belvedere Court, the setting for the then recently rediscovered antique *Laocoon* group, installed there in 1506. Raphael and Michelangelo answered the call, too. Raphael was commissioned to decorate three rooms in Julius' new apartments in the Vatican (the celebrated *Stanze*), while to Michelangelo, Julius entrusted the execution of his tomb*, the decoration of the vault of the Sistine Chapel*, and a bronze effigy of himself (see Bologna), as a reminder to the Bolognese of their bitter defeat. The statue was hastily toppled during the city's "liberation" in 1511; Bologna was finally and definitively annexed to the Papal States in 1512.

The restoration work in Rome came at a price, however, as Michelangelo discovered to his own cost when Julius II decided that the massive construction site for the new St. Peter's should take priority over everything else, including his tomb. St. Peter's proved so costly that the papacy launched an active campaign to sell indulgences throughout the Christian world, little suspecting that this would spark one Martin Luther to nail his objections to the doors of Wittenberg Cathedral, in 1517, and bring about the Reformation. Michelangelo fell into despair upon the suspension of work on Julius' tomb. He left Rome for Florence, letting it be known that "if ever [Pope Julius] wanted to see him in the future, he would find he had gone elsewhere" (Vasari*). Julius was forced to make allowances, and was eventually reconciled with Michelangelo in Bologna, commenting wryly that "instead of your coming to meet us, you have waited for us to meet you." Many years later, Michelangelo recalled his difficulties with Julius II in his letters*, attributing them to the jealousy of Raphael and Bramante. (HS)

Facing page: Jacopo Pontormo, after a cartoon by Michelangelo, *Venus and Cupid*, c. 1533 (Michelangelo's cartoon was produced in 1532–33). Oil on panel, 4 ft. 1¼ in. x 6 ft. 4 in. (1.25 x 1.93 m). Galleria dell'Accademia, Florence.

Raphael, *Portrait of Julius II*, c. 1511. Oil on panel, 42½ x 31¾ in. (108 x 80.7 cm). National Gallery, London.

■ POPE JULIUS II'S TOMB

In April 1505 Michelangelo went to Carrara to select the vast quantities of marble required for Pope Julius II's monumental tomb, to be situated in St Peter's. Vasari notes that Michelangelo "started work with very high hopes." It took some forty years for the project to reach its final resolution, however. Condivi's* famous reference to "the tragedy of the tomb" describes not only the project's somewhat unsatisfactory time scale, but also the anguish felt by the sculptor himself.

The tomb was to be a free-standing monument three stories high, featuring some forty statues. The first interruption came in April 1506 when Michelangelo fled from Rome to Florence following an argument with the pope (see Julius II). The years following their reconciliation were, however, subsumed by the painting of the Sistine Chapel vault*. After Julius' death in 1513, another contract was drawn up by his executors, detailing a scaled-down version of the tomb to be completed within seven years. It was at this stage that the Moses and the Dying and Rebellious Slaves or Captives (Musée du Louvre, Paris) were carved. Three years later a third contract led to a further reduction of scale; the other Slaves* are datable to this phase. Conflicting demands on Michelangelo contributed to an additional delay, and in 1532 the location of the tomb moved to the church of San Pietro in Vincoli. Further discussions and agreements ensued and the final contract was issued in 1542.

The tomb as it survives today is adorned with only three autograph works by Michelangelo: the Moses, and the figures of Rachel and Leah (respectively, the Contemplative and Active Life). The architectural framework was executed by Antonio del Pontesieve, and among the other sculptors working on the tomb were Raffaello da Montelupo and Tommaso di Pietro Boscoli. There is little coherence between these elements, and they sit uneasily in their architectural setting, which has been limited spatially by the lunette above.

The expressive force of the tomb lies solely in Michelangelo's works, notably the Moses, the impetus for which probably lay in the painting of the sibyls on the Sistine Chapel vault*. His complex pose and exaggerated length of waist can be explained by his intended position in the 1513 scheme: on a corner 13 feet (4 m) above the ground. It is possible that Michelangelo made some adjustments to take account of the new location, perhaps giving greater emphasis to detail. Indeed Vasari* praised the treatment of the beard, carved "as if the chisel had become a brush." Moses' psychologically charged facial expression is perhaps redolent of the notorious terribilità (see Vasari) of both Pope Julius and Michelangelo himself. Analogies would certainly have been drawn between Moses, bearer of the law, and his papal "successor."

The active and contemplative lives are embodied in the figures of Leah and Rachel. Condivi* relates that the attributes of Leah, a garland and a mirror, allude to another, literary, embodiment of the theme, namely Countess Matilda in Dante's Purgatorio. Much later than the Moses (c. 1542), these

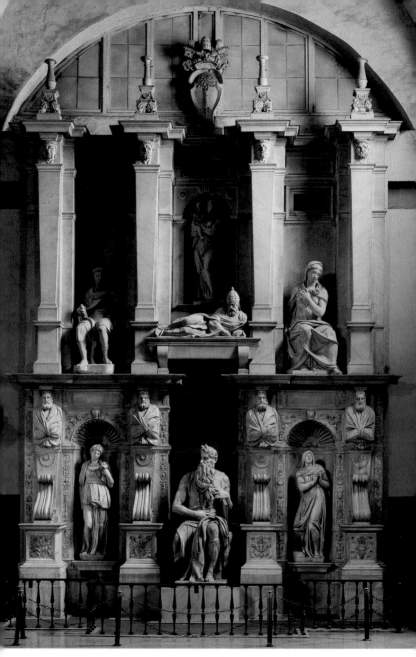

figures sit uneasily against his monu-
mental force, and are carved with
greater economy. Nevertheless, as she
lifts her eyes to heaven, the religious
fervor of Rachel is palpable, and her
powerful form is imbued with an
undeniable grace, most notably in the
delicate clasping of her hands. (AB)

Michelangelo, *Tomb of Julius II*.
San Pietro in Vincoli, Rome.

■ Porta Pia (1561–64)

The Porta Pia takes its name from the pontiff for whom it was built—Pius IV. Located inside the ancient walls of Rome, on the axis of the former Via Nomentana, which Pius had rebuilt, it is clearly decorative rather than defensive, perhaps taking its cue from the elaborate fake architecture and scenery that were a feature of contemporary civic festivals. The structure, part of a general scheme of rebuilding and urban regeneration, is remarkable in many ways: it represents a significant departure from the accepted forms employed for city gates, and features totally original decorations in travertine stone. The fluted and cabled pilasters flanking the central gateway are unclassifiable within the Vitruvian canon. Seemingly bereft of capitals, the latter in fact blend into the space assigned to the architrave, which is correspondingly marked with six Doric guttae, protruding from their supports. Towards the end of his life, Michelangelo challenged even the basic structural rules underpinning the classical "orders"— the combination of vertical and horizontal elements (columns and entablature). Here, the play of intersecting, incomplete, triangular and broken pediments, the effect of receding perspective achieved by the moldings and the pillars superposed upon them, are an extension of the quest for new, plastic forms which Michelangelo instigated in the *ricetto* of the Laurentian Library*. The gate is flanked at its extremities by brick "pillars" which extend rather like chimneys above the last level of horizontal moldings, terminating in Ionic capitals; these are set alongside a line of six variants of the same form, each surmounted by a ball (the Medici emblem). The upper register, unfinished at the time of Michelangelo's death, features an equally surprising central structure (rebuilt in the nineteenth century) rising above the main gateway. Here, smooth paired pilasters are prolonged by fluted sections into the space normally reserved for the capitals, which in turn occupies the space normally reserved for the architrave and frieze, the whole surmounted by a broken pediment with volutes. The central space between the pilasters is decorated with an oculus framed within a smooth band

Michelangelo, Porta Pia, Rome.

of stone forming an arch terminating in triangular guttae, a motif repeated on a smaller scale on either side of the gateway below. The Porta Pia develops an ornamental vocabulary that was freely used by generations of future architects. (FL/YP)

Portrait of the Artist

"Michelangelo's constitution was very sound, for he was lean and sinewy. ... His face was round, the brow square and lofty, furrowed by seven straight lines, and the temples projected considerably beyond the ears, which were rather large and prominent. His body was in proportion to the face, or perhaps on the large size; his nose was somewhat squashed, having been broken ... by a blow from Torrigiano; his eyes can best be described as being small, the color of horn, flecked with bluish and yellowish sparks. His eyebrows were sparse, his lips thin (the lower lip being thicker and projecting a little), the chin well formed and well proportioned with the rest, his hair black but streaked with many white hairs and worn fairly short, as was his beard, which was forked and not very thick." Vasari's description corresponds to the few known portraits of Michelangelo, none of which were made during his youth. Michelangelo was not interested in portrait painting, and he does not seem to have been called upon to paint his own portrait. He did, however, allow others to paint his likeness. Vasari notes that he agreed to sit for Giuliano Bugiardini, in order to please Bugiardini's patron, Ottaviano de' Medici. The sittings took place in Florence, possibly around 1532, or ten

years earlier: an inscription on the version of the painting now in the Louvre, identified as a *Portrait of Michelangelo Wearing a Turban*, notes that the artist is shown at the age of 47. Another portrait (now at the Casa Buonarroti, Florence) was painted in Rome, around 1535, by Jacopo del Conte. This austere image, showing Michelangelo aged 60, is also mentioned by Vasari, along with the bronze bust, possibly based on a death mask, by Daniele da Volterra*, and the beautiful medal made by Leone Leoni in Milan, in 1561, showing the artist's right profile. Vasari confirms that these are the only known portraits of Michelangelo, but that they were extensively copied, so that he had seen numerous versions in Italy and elsewhere. He makes no mention of a portrait supposedly by Bandinelli, to whom some critics attribute both the *Portrait of Michelangelo Wearing a Turban* in the Louvre, and a related drawing (also in the Louvre), but which had also been cited as a self-portrait. Vasari says nothing, either, of the self-portraits which Michelangelo occasionally

Baccio di Bandinelli (attributed to), *Portrait of Michelangelo*. Oil on panel, 19⅓ x 14¼ in. (49 x 36 cm). Musée du Louvre, Paris.

slipped into his own works. Two examples in the Sistine Chapel are the figure of Sadoc, in the lunette of Sadoc and Azor, and the uniquely tragic, distorted face on the flayed skin of St. Bartholomew, in the *Last Judgment**. The artist's features have also been identified in the unfinished *St. Matthew* (Florence, Galleria dell'Accademia), and in the face of Nicodemus in the Florentine *Pietà* (Museo dell'Opera del Duomo, Florence), a work which Michelangelo had intended for his own tomb, but which he later broke into pieces, "either," says Vasari, "because it was hard and full of emery and the chisel often struck sparks from it, or perhaps because his judgment was so severe that he was never satisfied with anything he did." (HS)

■ Rondanini Pietà

This Pietà is the only indubitably authentic work datable to Michelangelo's last years. It was begun after 1552 and probably resumed in 1555. Daniele da Volterra* reported that Michelangelo was at work on the group only five days before his death, at which point it remained incomplete. As with the Duomo *Pietà*, Michelangelo mutilated the work, undoubtedly dissatisfied with the resolution of form. The initial stage of conception depicted Christ's body sagging forward, but to the left of the figure of the Virgin. The fully worked arm to the left of the composition is all that remains. The head and part of the torso from this earlier scheme were discovered in 1973 (Palazzo Vecchio, Florence) and perfectly match the truncated arm. The later reworking shows the figure of Christ drawn backwards, with His body absorbed against that of the Virgin, similar in composition to fourteenth-century Florentine pictorial prototypes. This sense of paring down is also visible in some studies relating to the *Rondanini Pietà* in the Ashmolean Museum, Oxford (no. 339).

The sculpture is an intensely private work, although we know that it was promised in August 1561 to one of Michelangelo's servants. The simplicity and columnar formation of the group has led to comparisons with Gothic and Northern prototypes, possibly symbolising the artist's ultimate renunciation of Italian Renaissance aesthetic principles, which were based on "pagan" classical art. This is a plausible theory which reflects Michelangelo's growing preoccupation with issues of redemption and salvation, also conveyed in his poetry*. The group has also been interpreted as an expression of Michelangelo's belief in the need for reform in the Roman Church, in the context of the rise of "Northern" Protestantism (see Evangelism), but this seems improbable and confuses the relationship between Christianity and Gothic art forms. (AB)

■ San Giovanni dei' Fiorentini and the Late Roman Works

In 1559, Michelangelo presented a number of studies for a church for the Florentine community in Rome, based on a centralized plan with a massive, cubic exterior crowned by a lantern. It was never built. During the same period, he designed a centralized plan for the Sforza Chapel at Santa Maria Maggiore. The latter

Michelangelo,
Rondanini Pietà,
c.1552–55.
Marble,
h. 6 ft. 4¾ in.
(1.95 m).
Museo del
Castello Sforzesco,
Milan.

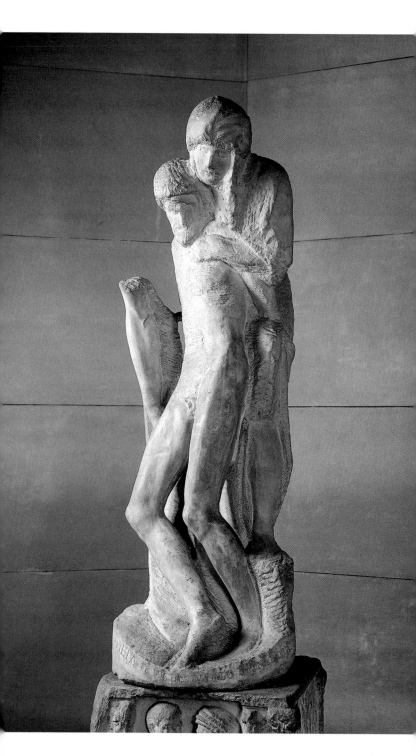

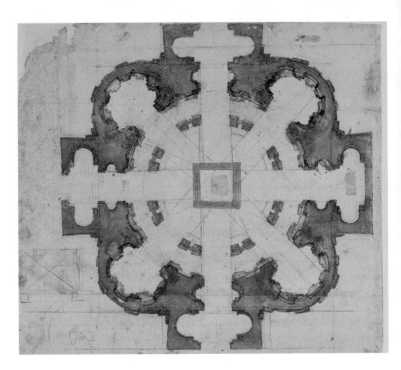

Michelangelo,
*Plan for
San Giovani dei
Fiorentini*,
c. 1559.
Black pencil.
Casa Buonarroti,
Florence.

succeeded in emphasizing the central axis of the main structure, defined by the entrance and the main chapel housing the altar, while at the same time not neglecting the longitudinal axis, with secondary chapels placed at the latter's extremities. Moving the crossing towards the entrance enabled Michelangelo to enlarge the side chapel, for improved lighting. The crossing was surmounted not by a dome, but by slightly flattened pendentive arches. The plan itself is highly original, and the dynamic use of columns delighted and influenced future generations of architects.

Of the church created by Michelangelo within the great hall of the Baths of Diocletian, only the arches remain. Compelled for reasons of economy to make best use of the existing structures, Michelangelo used the rotunda situated to one side of the long hall as the main vestibule, entered from the Via Pia, and placed the altar opposite. The choir at the back was thus "screened" from the public space by two antique columns, in perfect accordance with the Carthusian liturgy with which the church had been consecrated. The choir could also be entered from the cloister built on the site of the ancient *frigidarium*. Secondary entrances to the church were created at the hall's extremities. Michelangelo created a functional church using a Greek cruciform plan, on an axis perpendicular to the great hall of the Baths. He succeeded in making the best of the volumes and spaces of the grandiose antique ruins, to the greater glory of the Roman church. (FL/YP)

■ Sangallo and the Setta Sangallesca

Michelangelo was a famously difficult character; relations with his colleagues and rivals, especially Bramante and Raphael, were always delicate. But with the architect Antonio

da Sangallo and his circle (scornfully nicknamed by Vasari* the *setta Sangallesca*, or "Sangallo's sect"), tensions reached new heights.

In the face of Michelangelo's inventiveness and creative freedom, Sangallo highlighted his own technical competence, the effectiveness of his architectural solutions, his comparative rigor in the application of the Vitruvian principles of ornamentation. The clash of personalities was less apparent during Sangallo's life, however, than after his death in 1546, when Michelangelo took charge of his rival's two major architectural projects, the Farnese Palace*, and St. Peter's basilica. In the case of the latter, Michelangelo not only abandoned Sangallo's plans completely, in favor of his own radically different artistic approach, but also fired his predecessor's entire workforce, spurring a violent polemic. One anonymous letter vehemently denounced Michelangelo's "irregular," poorly-proportioned outer cornice at the Farnese Palace. The self-proclaimed spokesman of the *setta Sangallesca*, Nanni di Baccio Bigio (architect of the Villa Ricci which, transformed by Ammannati, subsequently became the Villa Medici), questioned Michelangelo's technical competence as evidenced by work at St. Peter's, and accused him of wasting money. Nanni proudly vaunted his own skills, by contrast. Had he not taken just fifteen days to complete work on Michelangelo's unfinished Ponte Santa Maria, to the admiration of all Rome? (The bridge subsequently collapsed during a flood in 1557.)

Taken out of the context of their time, such posturings seems rather pointless; they serve, nonetheless, to highlight the originality of Michelangelo's architecture, in the eyes of his contemporaries. (FL/YP)

Antonio da Sangallo (after Michelangelo), plan for St. Peter's basilica.

Bartolemeo della Porta, *Portrait of Giraloma Savonarola.* Museo di San Marco, Florence.

■ Savonarola

According to Condivi*, Michelangelo was much influenced by this Dominican friar, preacher, and writer. Born in Ferrara in 1452, Savonarola studied theology at San Domenico in Bologna, but in 1490 was transferred to San Marco in Florence at the behest of Lorenzo de' Medici ("the Magnificent"). Here he became prior in 1491 and earned renown for his skill as a charismatic orator. In his sermons, letters, and treatises, he reflected on the function of art and extolled the virtues of nature over inferior man-made works. In his *Prediche Sopra Amos* (1497), he railed against the common artistic practice of using living models for holy personages. He was also clearly pro-republican, advocating the overthrow of tyrants and an end to corruption within the Church.

In truth, Lorenzo had unwittingly invited his own nemesis into the city. Savonarola had predicted the downfall of the Medici*, and his pro-republican oratory stirred up considerable anti-Medici feeling. The dynasty did not survive Lorenzo's death for long, and was overthrown in 1494. Savonarola now became the sole leader of Florence, setting up a democratic republic. He was forbidden to preach by Pope Alexander VI, excommunicated on June 18, 1497 and charged with heresy one year later. He was executed in Florence, on the Piazza della Signoria.

Michelangelo would have heard Savonarola's sermons while working in the service of the Medici; according to Condivi, he could still remember them in old age. Michelangelo was certainly sensitive to issues of piety, especially in his later years, but it seems unlikely that he was one of Savonarola's faithful disciples, although there are certain parallels in their views. Beyer has noted the "stern grandeur" of Michelangelo's Madonnas, for example. The early *David** is firmly republican in spirit, but its frankly pagan, heroic character—and nudity—are clearly contrary to Savonarola's aesthetic ideas as expressed in the *Prediche*. (AB)

■ Sculpture

Michelangelo's quest for perfection in sculpture began with a creative conceptual process, formulating ideas in a series of drawings and *modelli**. It was important to create a formal conception of the design before sending specifications to the quarries at Carrara and

Anonymous, *Execution of Gerolamo Savonarola on the Piazza della Signoria.* Oil on panel, h. 3 ft. 7in. (1.10 m).

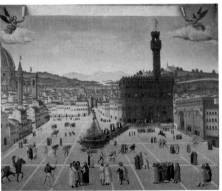

elsewhere. According to Vasari* and Condivi*, Michelangelo spent several years of his life, in total, selecting marble and overseeing the quarrying.

That Michelangelo always began to carve from the principal face of the block, as though uncovering a relief, is to some extent a myth propagated by Cellini and Vasari*. Certainly the *St. Matthew* (begun c. 1505) "emerges" from the marble and a backdrop of geometrically opposed claw marks, and the "pattern" created by these marks reflects those created by pen and ink in his drawings. The *Atlas Slave* (Accademia, Florence), however, has been carved from two adjacent faces of the block simultaneously, and the *Bacchus* (Bargello, Florence) was carved diagonally across the block, from front left to back right. This method had been hinted at in the formative years of Michelangelo's career, in the *Angel Holding a Candlestick* (S. Domenico, Bologna,). His *modus operandi* was therefore adapted to suit the nature and purpose of the commission and cannot be restricted to the method outlined by his biographers.

The sixteenth-century French writer, Blaise de la Viginère, described the emotion and intensity which Michelangelo displayed when carving marble, but it should be noted that the sculptor was very old at the time of this report and perhaps working on a private piece (such as the *Rondanini Pietà*) or even roughing out a new block. This description, therefore, cannot be applied globally to his working method.

Although works were carefully planned—necessitated by the expense of the marble—there is evidence of some willingness to diverge from the prototype. Both the *Taddei Tondo* and *St. Matthew* reveal adjustments in the modeling and a rear view of the *David* shows *pentimenti* in the left-hand edge of the sling. Finish, however, was a responsibility of the workshop, which on occasions led to substandard results, notably in the case of Pietro Urbano's involvement in the *Risen Christ* (Santa Maria sopra Minerva, Rome). (AB)

Michelangelo, *Study for a River God*, c. 1525. Pen and brown ink, 5⅓ x 8⅓ in. (13.7 x 20.9 cm). Department of Prints and Drawings, British Museum, London.

■ SIEGE OF FLORENCE
Michelangelo as chief architect of the fortifications

The revolution that drove the Medici out of Florence and established the Florentine republic (May 16, 1527) was the first direct outcome of the conquest of Rome on May 6, 1527, by the imperial armies of Charles V of France (part of the anti-papist Holy League), and that city's subsequent sack once Pope Clement VII (Giulio de' Medici) had taken refuge in the Castel Sant'Angelo. In October 1529, it was Florence's turn to face the imperial forces, now allied to Clement, who had succeeded in finding common ground with Charles V at the Treaty of Barcelona on June 29, 1529. Clement now sought to reinstate the Medici as rulers of the city. Caught in a desperate struggle, Florence nonetheless held out for ten long months before capitulating on August 12, 1530. Throughout these events, Michelangelo, who supported the republic and had been elected governor-general of the fortifications, showed total commitment to his causes (setting aside the ambiguous episode of his flight to Venice in September 1529 as part of a plan to join the court of François I in France, and which, according to Condivi*, "caused a scandal in Florence"). In the third of Francisco de Holanda's* Roman dialogues, Michelangelo is quick to vaunt the efficiency of his defenses, particularly those on the hillside at San Miniato, which are described in detail by Condivi. We also have the remarkable series of drawings for a scheme of preventive fortifications preserved at the Casa Buonarroti, nothing or little of which was ever built. The plans and drawings are extremely beautiful, but beyond their immediate aesthetic appeal, they demonstrate the artist's quest for highly individual, evocative solutions—such as the bastions with which he had hoped to defend the city's extremities, and which have been compared to monstrous crustaceans, waiting to seize the enemy in their claws. Clearly, Michelangelo's vision tended more towards the notion of attack than defense—a striking departure for the time. (HS)

■ Sistine Chapel Vault

In May 1508 Michelangelo signed a contract to decorate the vault of the Sistine Chapel. He was to replace the original decoration—gold stars on a blue background—which had been executed under Pope Sixtus IV, the uncle of Pope Julius II*. The ceiling was complete by October 31, 1512. This lengthy execution period can in part be explained by the problem of mold on the wet plaster in the early stages, and also the year long gap between 1510 and 1511, when Michelangelo went to Bologna* in order to petition the Pope due to lack of funding.

Along the central section of the nave runs a continuous narrative taken from the Old Testament book of Genesis. The scheme can be divided thematically into three groups of three: the creation of the universe, the creation of mankind, and the story of Noah. The seventh scene, which marks the beginning of this last phase, is somewhat problematic; Condivi* described it as the *Sacrifice of Abel*, although it is more commonly known as the *Sacrifice of Noah*, although this explanation places it out of chronological sequence.

The narrative begins with *The Separation of Light from Darkness* at the altar end, although *The Drunkenness of Noah*, closest to the entrance, was the first to be painted. *The Creation of Eve* was painted above the chancel screen, and in this way, pre-lapsarian images were contained within the sanctified area of the choir. Each scene is differentiated by a painted architectural framework into which are incorporated seated nude youths or angels, known as the

ignudi. These figures support large bronze roundels depicting Old Testament stories, and some also bear garlands of oak leaves, an emblem of Pope Julius's family, the della Rovere. In alternate spandrels beneath the main sequence are prophets and sibyls who foretell the coming of Christ and demonstrate His relevance to both Jewish and pagan worlds. Between them, and in the lunettes above the windows, are depicted the human ancestors of Christ. The pendentives in the corners contain images depicting the salvation of Israel, including the infamous, foreshortened image of the *Execution of Haman*.

The vault is a technical tour de force, whose often dramatically foreshortened figures defy both conventional perspective and the spatial complexities of their setting within the real architecture of a barrel-vaulted ceiling. Vasari claims that Michelangelo labored in solitude, without so much as an assistant to mix his colours, but in fact, he almost certainly had assistants working for him (see Painting) but under strict supervision.

The last four bays, however, are more monumental in scale and minimal in content when compared with the earlier, densely populated scenes, which adhere to the principles of history painting as laid down by Leon Battista Alberti in his treatise of 1436, *Della Pittura* ("On Painting"). The prophets and sibyls are similarly enlarged, breaking the boundaries of their architectural settings. This stylistic shift is datable to Michelangelo's return to the project in 1511. It is possible that he considered the early figural compositions too detailed;

Facing page:
Michelangelo,
Fortification Scheme for the Porta al Prato d'Ognissanti,
1527.
Pen and brown ink, brown wash and red chalk,
15⅓ x 22 in.
(38.8 x 55.8 cm).
Casa Buonarroti,
Florence.

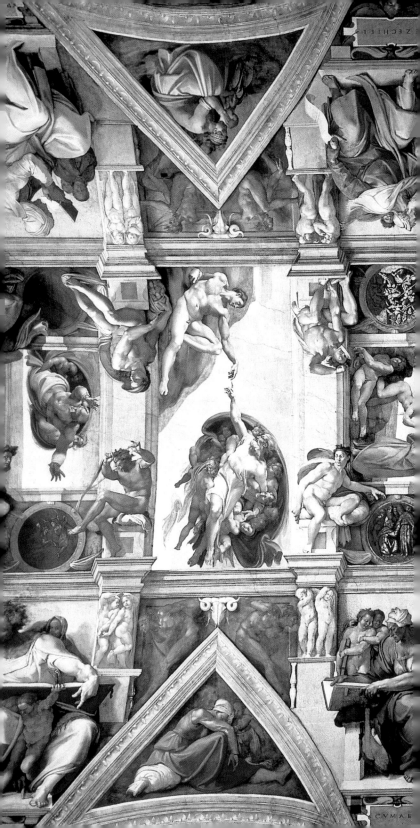

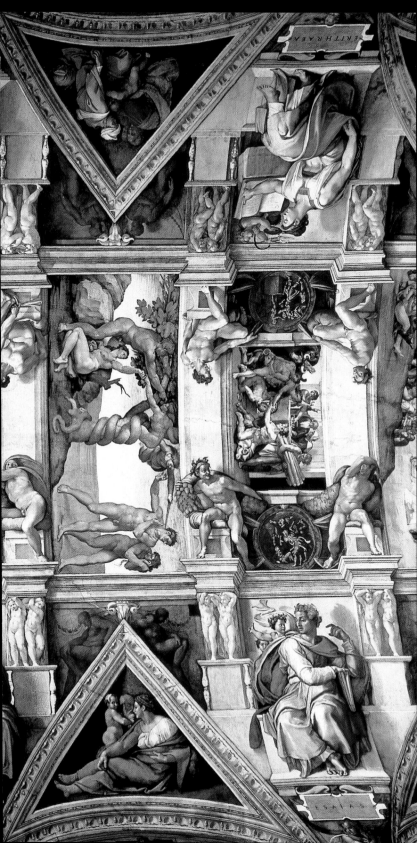

ERITHRAEA

ESAIAS

Pages 104–105:
Michelangelo,
Sistine Chapel
vault. Fresco,
132 x 44 ft.
(40.23 x 13.4 m).
Sistine Chapel,
Vatican.

> *I've already grown a goiter at this drudgery—*
> *as the water gives the cats in Lombardy,*
> *or else it may be in some other country—*
> *which sticks my stomach by force beneath my chin.*

Michelangelo, sonetto caudato
(sonnet with an additional three-line "tail")
describing the effects of work on the Sistine Chapel vault,
sonnet no. 5, trans. Saslow.

certainly, these later images demonstrate an increased confidence in the fresco medium.

Thematically the scheme complemented existing frescoes on the walls below, commissioned by Pope Sixtus IV and which depicted a series of episodes from the lives of Moses and Christ. An earlier plan for the vault, depicting the twelve apostles, had been devised by Julius II but was ill received by Michelangelo. It is unlikely, however, that the final scheme was formulated by Michelangelo himself; it was probably left to a papal advisor. (AB)

■ Slaves

The four *Slaves*, (labeled *Young, Bearded, Atlas,* and *Awakening*) now in the Galleria dell' Accademia, Florence, formed part of the 1516 scheme for the tomb of Julius II*. It has been suggested by Kriegbaum that only two out of the four are authentic, although this is by no means the consensus. According to one of Michelangelo's Roman correspondents, Leonardo Sellaio, the sculptor was to start working on four tomb figures in the summer of 1519. They were, however, never finished and remained in Michelangelo's workshop until his death.

In comparison with the Louvre figures, sometimes differentiated as *Captives*, the *Slaves* are larger in scale, with an increased sense of heroic masculinity. This is no doubt due to their function, which was to support the entablature of the tomb on each of the four corners. Perhaps because of this, the block of marble was carved at a projecting angle, and thus two sides were worked upon simultaneously (see Sculpture). Typically, in these unfinished works, the bodily form, and in particular the torso, has been most fully articulated.

The heroic proportions of these figures, especially in *Bearded* and *Awakening Slave*, have prompted discussion that they may anticipate the figurative style of the *Last Judgment**, or are even contemporary with it. This mistaken hypothesis relies on the assumption of a linear stylistic sequence in Michelangelo's work: in fact, this kind of traceable "development" is significantly absent in his work. In addition, the design must have been formalized by 1519, when the blocks of marble had already been roughed out at the quarry and delivered to Michelangelo's workshop. Caroline Elam has noted that this "heroic" type was most probably informed by ancient prototypes, whereby older men are often depicted with greater muscular emphasis. (AB)

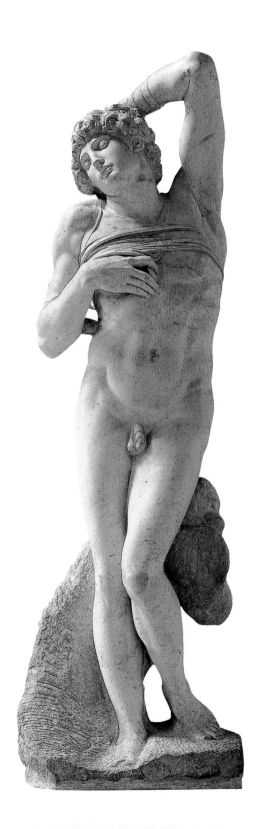

Michelangelo,
Dying Slave,
c. 1513. Marble,
h. 7 ft. 5 ¾ in.
(2.28 m).
Musée du Louvre,
Paris.

■ ST. PETER'S PIETÀ

The group often referred to today as the *St. Peter's Pietà* took a peripatetic journey around the basilica before being installed in 1749 in its present location, in the chapel nearest to the west door on the south side of the nave. It was seen by both Vasari* and Condivi* in the chapel of the Madonna delle Febbre, but had originally occupied a chapel dedicated to St. Petronilla near the sacristy of Old St. Peter's, described by both authors as occupying the site of an ancient temple to Mars. Commonly known as the "chapel of the King of France," the building was demolished in 1520 but had been the chosen last resting place of the Cardinal of St.-Denis, Jean Villier de la Grolaie (c. 1430–99), who came to Rome in 1491 as Charles VIII's ambassador to the Holy See. He is described by Vasari as having asked Michelangelo to make "a Pietà of marble, in the round." The French cardinal seems likely to have influenced the group's iconography, which reflects a Germanic tradition first seen in the fourteenth century, and which spread throughout France before being introduced into Italy. The contract for the work was signed on August 27, 1498, in the presence of Jacopo Galli (who had acquired the *Bacchus**), who acted as guarantor. However, Michelangelo had already visited Carrara nine months earlier to select the marble personally: a shallow block—which suggests that the Pietà was originally intended for a niche—and one of exceptional quality. The group's resplendent surface is the result of long and careful polishing, and in this sense, the Pietà is certainly Michelangelo's most "finished" work, executed with extraordinary finesse. Of all his works, it is the most uniquely detailed; unique, too, in having been signed by the artist, whose name is carved into the band across the Virgin's chest. "It is certainly a miracle, that a formless block of stone could ever have been reduced to a state of perfection that nature is scarcely able to create in the flesh," wrote Vasari, after a careful elucidation of the group's most notable features: its technical virtuosity, the extraordinary richness of the drapery enveloping the Virgin's form, the remarkable anatomical accuracy of the figure of Christ. He is astonished, too, that the group could be completed "in so short a time," namely one year, as per the terms of the contract. Michelangelo does not seem to have delivered the group within a year, however his receipt of a significant payment on July 3, 1500 may indicate that his task was finally accomplished slightly less than a year after the stipulated completion date. (HS)

Michelangelo, *Pietà*, 1498–1500. Marble, h. 5 ft. 8⅓ x 5 ft. 5⅓ in. (width at base) (1.74 x 1.66 m). St. Peter's, Vatican.

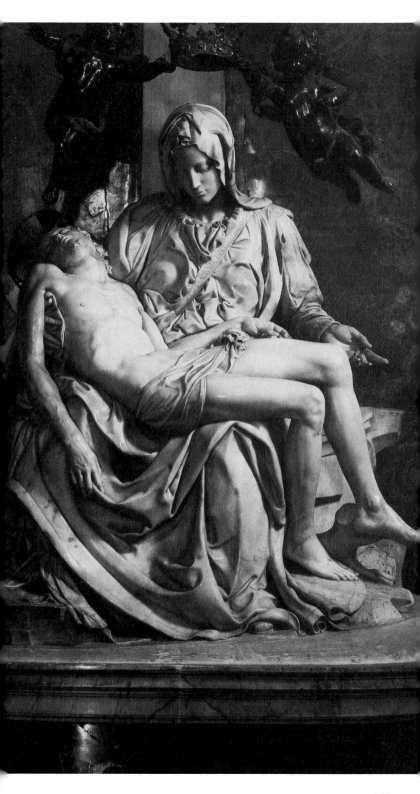

■ ST. PETER'S, ROME

Begun by Julius II upon his election as pope, with Bramante as head architect, work on the new basilica of St. Peter's came under the successive directorship of Raphael, Peruzzi, and Sangallo*. At the time of the latter's death in 1546, the church was only partially built: various plans had been tried out around the powerful pillars of the crossing and Bramante's unfinished choir, but none proved conclusive. Sangallo spent a great deal of time and money on a monumental model, and began the construction of the outer walls.

Michelangelo undertook to carry the project forward on condition that he was placed in sole charge. Much was at stake, both artistically and financially, not to mention the enormous religious and moral implications of the job of master of works for the greatest basilica in Roman Christendom. For these reasons, Michelangelo immediately discarded Sangallo's ideas and distanced himself from the members of the so-called *setta Sangallesca**, demolishing everything that his predecessor had built. He submitted a new model to the pope, which was approved.

The new plan abandoned earlier designs based on the Latin cross, returning to Bramante's first idea: a Greek cross inscribed within a square, which Michelangelo simplified greatly, imbuing the interior volumes with the greatest possible coherence, light and majesty. For the exterior, he chose to replace Bramante's Doric orders with massive Corinthian pilasters supporting an attic story. The outer walls adhere closely to the inner volumes, but display an angularity of movement quite unlike the smooth planes preferred by Renaissance architects. As such, they proved highly influential for seventeenth-century architecture. Michelangelo's plan for the west front consisted of two stories of columns supporting a pediment; his dome would doubtless have been squatter in silhouette than the structure finally built by Della Porta.

The plans did not correspond to the liturgical demands of the Counter-Reformation, however, and could not be carried out in their original form. The Greek cross was extended at the beginning of the seventeenth century, with the addition of an extra span and a vast narthex by Carlo Madena, the architect of the west front that we see today. This had the unfortunate effect of obscuring the dome for worshippers arriving at the west door—a loss of dramatic impact partially remedied by Bernini's majestic piazza. Despite the wealth of ornament, far beyond what was originally planned, St. Peter's today still owes much to the intervention of Michelangelo. (FL/YP)

Chevet, St. Peter's basilica, Vatican City.

■ Varchi, Benedetto

Benedetto Varchi (1503–65), humanist, historian, philologist, and poet, was one of the brightest minds of his day. Despite his republican sympathies—he joined the exiled Florentine camp following Alessandro de' Medici's assassination (see Gianotti)—he was a protégé of Duke Cosimo I, who commissioned him to write a history of Florence (the *Storia Fiorentina*, eventually published in 1721), having called him back to the city in 1543 to work for the highly official Accademia Fiorentina (see Accademia del Disegno).

Titian, *Portrait of Benedetto Varchi*. Kunsthistorisches Museum, Vienna.

The year 1549 saw the publication of two celebrated lectures delivered to the Accademia in spring 1547. The first is a commentary on Michelangelo's sonnet, *"Non ha l'ottimo artista alcun concetto …"* ("Not even the best of artists has any conception…"). The second deals with the *paragone* or "comparison" between painting and sculpture, "being a debate to discover which is the more noble art, sculpture or painting." In an appendix to the work, Varchi publishes a letter from Michelangelo, "and several other Most Excellent Painters and Sculptors upon the said question," the result of a survey carried out by Varchi among artistic circles in Florence.

Michelangelo's immense authority, and above all his acknowledged excellence as a sculptor, rekindled the old debate (of which painting was more frequently the winner), both within the profession and in society at large. As the new, self-appointed arbiter in the matter, Varchi's personal view was that "from a philosophical standpoint … sculpture and painting are, in substance, one and the same art, and consequently each as noble as the other," since they share the same ultimate objective, "an artificial imitation of nature," based on the same fundamental principle, "namely, drawing." This was his conclusion.

Unlike his fellow artists, who each defended their own particular specialty, Michelangelo had no truck with Varchi's game. His response to the lectures is concise. Michelangelo, painter and sculptor, appears to agree with the eminent academician, but is not afraid to stress the futility of such squabbles, which were, he said, "time-wasting." Art was all that mattered. (HS)

■ Vasari, Giorgio

Michelangelo said of his friend, "Vasari, on his own, does the work of a thousand men, or more." Giorgio Vasari (1511–74) was blessed with wide-ranging talents and a quick, inquiring mind; he was also a skilful courtier and diplomat, and a prodigious, fast worker capable of forging a highly successful and perennially fascinating career. He was a painter, decorator, architect, writer, historian, theorist, and collector. He is known above all for his role as Cosimo I's political and cultural propagandist, but was also omnipresent in the public life of his time, meeting everyone, missing nothing—as witnessed by both his correspondence with virtually every major contemporary personality and his great masterwork:

Le Vite dei più eccellenti pittori, scultori ed archittettori (*The Lives of the Most Eminent Painters, Sculptors, and Architects*).

Published in two editions, Vasari's *Lives* are a monument to the glory of Michelangelo, the only living artist chronicled in the first edition (the *Torrentiniana*, 1550, 2 vol.), of which his is the crowning and concluding "life." For Vasari, the "incomparable," unsurpassable Michelangelo, that "unique sculptor, sovereign painter and true master of architecture," represented the culmination of the ascent of art to a state of absolute perfection—hence his fear of an impending, inevitable fall from such dizzy heights. In the second edition (the *Giuntina*, 1568, 3 vols), his perspective has altered and Vasari adds the lives of artists "living and dead, from the year 1550 until 1567," finishing this time with his own autobiography. The biography of Michelangelo (which was also published as a separate volume) remains, nonetheless, by far the longest and most important of the *Lives*. Considerably expanded from the 1550 edition, the new version takes account of Condivi's* documentation and text, and traces Michelangelo's career over seven decades, ending with a lengthy description of his funeral* ceremony in 1564. In it, Vasari proclaims his admiration for his "master and friend," defending him against his detractors, attackers, and critics. His repeated references to "*il divino*," and the "*terribilità*," the terrifying greatness, of his art, coined the critical keywords for generations of Michelangelo's admirers to this day.

Vasari's first account seems to have succeeded in annoying its subject—Condivi states that "some" other writers have "said things about Michelangelo which were never so"—nonetheless, the two men still encountered each other frequently on numerous projects in Rome. Vasari continued to vaunt his increasingly close ties of friendship with Michelangelo; eventually (under pressure from Cosimo), he tried to convince him to return to Florence, but without success. (HS)

Giorgio Vasari, *Self-portrait*. Oil on canvas. Galleria degli Uffizi, Florence.

Venusti, Marcello

Frequently referred to in the sources as "Mantovano" (from Mantua), Marcello Venusti (c. 1512–79) was in fact from Como, in Lombardy. It is not known exactly when he met Michelangelo, but 1542 is a possibility, at the beginning of work on the Pauline Chapel*. Venusti's copy of the *Last Judgment** (Museo Nazionale di Capodimonte, Naples), originally for the private chapel of Paul III in the Farnese Palace in Rome, dates from 1549. The Sistine Chapel fresco was copied endlessly by its many admirers, but Venusti's is the only surviving "eye-witness" account of the composition in its original state, before the figures were discreetly veiled (see Censorship). Baglione reported that "Venusti has done a good job; Buonarroti seemed fond of him, and asked him to make many other copies." Seemingly, the "copies" in question were in

fact original paintings made from cartoons or drawings supplied by Michelangelo. This is certainly true of the two large-scale "Roman" *Annunciations* which Vasari* says were executed by Venusti after drawings commissioned from Michelangelo by Tommaso de' Cavalieri*: one for the Cesi Chapel in Santa Maria della Pace (now lost), and the other—of great quality—for the church of San Giovanni in Laterano (still *in situ*). In complete contrast, are the several, small-scale painted versions of drawings given by Michelangelo to Vittoria Colonna*: one version of the image of the Holy Family known as *Il Silenzio*, now in the Leipzig Pinakotek, is signed and dated 1563. Another in the National Gallery, London is thought to have been painted around 1565.

Marcello Venusti (from a drawing by Michelangelo), *The Holy Family*, known as *Il Silenzio*, c. 1565. National Gallery, London.

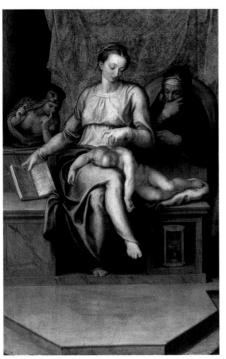

Due to his work for Michelangelo (admittedly a significant part of his output), Venusti is too often dismissed as a painter of replicas or derivations from the latter's designs and compositions. Yet he never ceased to work as an original painter in his own right—much appreciated and in demand, he carried out work for a number of churches in Rome. His masterpiece is the decoration of the vault of the Capranica Chapel in Santa Maria sopra Minerva (c. 1573). (HS)

■ Victory

The dating of the *Victory* is uncertain, but it was probably executed between 1519 and 1530 and remains unfinished. It is one of Michelangelo's most dynamic works, expressing power while retaining elegance of form. Michelangelo has combined a helical and pyramidal structure to create a spiralling *figura serpentinata*, a format that was to inspire Giambologna later in the century. The contorted form of the idealized youth is energized by his billowing drapery, while his steadfast expression determines the resolution of his cause. The angular, bearded features of the vanquished have been likened to those of Michelangelo, but it seems improbable that the sculpture served as any form of personal statement.

The function of the group is questionable, although it seems probable that it was intended for a niche setting. Vasari* had assumed that it was intended for the tomb of Pope Julius II* and indeed the youth wears a wreath of oak leaves, a papal symbol. The preparatory drawings for the tomb, however, depict winged female Victories

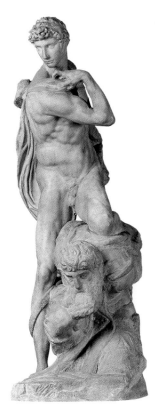

Michelangelo,
Victory. Marble,
h. 8 ft. 6 ¾ in.
(2.61 m).
Palazzo Vecchio,
Florence.

Sala Regia (interrupted by Perino's death in 1547, and which Michelangelo himself left unfinished), and the *Atrio del Torso*, in the Vatican. Michelangelo found a faithful disciple in Daniele, who (Vasari* notes) copied his works and followed his precepts. The master's influence is clearly seen in the *Descent from the Cross* (c. 1545), Daniele's most famous work and all that remains of the fresco and stucco decoration of the Orsini Chapel at SS Trinità dei Monti in Rome, a project which he took some seven years to complete. The monumentality and plasticity of Volterra's figures are clearly the product of a prolonged meditation on the late style of Michelangelo, to whom the composition was, indeed, attributed for some years.

From his increasingly close links with Michelangelo post-1550, Volterra reaped above all else the latter's eminently sculptural sense of form. His numerous individual figure studies are an eloquent expression of his heart-felt belief (handed down by Michelangelo) that "painting approaches perfection only in so far as it approaches the art of sculptural relief." The same is true, too, of his extraordinary *David and Goliath* (in Fontainebleau, c. 1555–56), for which Michelangelo provided working drawings. This double-sided painting, showing the group from two opposing viewpoints, was conceived as a response to the contemporary debate on the artistic supremacy of painting or sculpture (the *paragone*, see Varchi), a subject which the picture's patron, the cleric Giovanni della Casa, was perhaps planning to address himself in a forthcoming

and hence no precise conclusion can be drawn. The allegorical meaning is similarly unclear, but had it been intended for a funerary context, themes connected with the triumph of Christian principle over death or sin would have been appropriate. (AB)

■ Volterra, Daniele da

Trained in Volterra and Siena, Daniele da Volterra (also known as Daniele Ricciarelli) came to Rome around 1535 and quickly assumed a leading role in the execution of the city's grand decorative schemes in fresco and stucco, working at first in the studio of Perino del Vaga (between 1537–38 and 1543). It was probably through Perino that he first met Michelangelo, who later commissioned him to carry out a number of important projects, notably the decoration of the

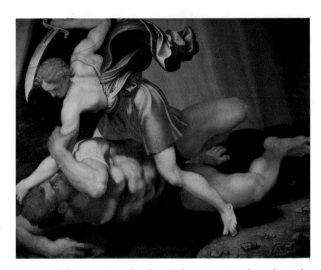

Daniele da
Volterra,
*David and
Goliath*
(above left and
right), 1555–56.
Slate,
4 ft 4 ⅓ in.
x 5 ft 7 ¾ in.
(1.33 x 1.72 m).
Musée Nationale
du Château,
Fontainebleau.

treatise. The painting clearly reveals Volterra's interest in sculpture, to which he subsequently devoted himself exclusively, working on his design for a bronze equestrian monument to Henri II of France (now in the print collections of the Rijksmuseum in Amsterdam) under the auspices of Michelangelo, who had recommended him personally to the monarch's spouse, Catherine de' Medici. Only the horse was eventually cast, in the winter of 1565 (it was sent to France in 1639, and destroyed during the Revolution). Volterra's reputation as a sculptor rests on a single work, the moving bronze portrait of Michelangelo (1564–66), possibly based on a death-mask, and widely interpreted as his personal homage to the master whom it was his privilege to serve in his last years. After Michelangelo's death, it was Volterra who carried out the inventory of his personal belongings in the house on Piazza Macel de' Corvi, where he lived subsequently. The thankless task of veiling the *Last Judgment*'s nudes also fell to Volterra, earning him the nickname "*braghettone,*" or "codpiece". (HS)

Wit and Wisdom

In the second edition of his *Life of Michelangelo*, Vasari devotes several pages to the master's quips and witticisms. Anecdotal, entertaining and shrewd, they also embody his essential artistic precepts:

"[Michelangelo] was once shown a drawing done by a novice whom it was hoped he would take an interest in, and seeking to make excuses for the boy, his sponsors said that he only just started to study the art. Michelangelo merely said: 'That's evident.' He said the same kind of thing to a painter who had produced a mediocre *Pietà*, remarking that it was indeed a pity to see it."

"When he was told that Sebastiano Luciano [del Piombo] was to paint a friar in the chapel of San Pietro in Montorio, he commented that this would spoil the place; and when he was asked why, he added that